inspiration to paint
WATERCOLOURS

Design copyright © Brenda Dermody. Design and layout by Brenda Dermody except pages 24–31, 66–73 and 114–121 layout by Paul Kellett. Cover by Design Revolution.

Production and separations in Singapore by ProVision Pte. Ltd. Tel: +65 334 7720. Fax: +65 334 7721.

inspiration to paint
WATERCOLOURS

betsy hosegood

RotoVision

contents

Introduction

By showing how different artists utilise the vibrant qualities of watercolour to produce a range of superb paintings, each in their own special way, this book reveals the many possibilities of watercolour. If you need inspiration and feel that your watercolours lack life or if you simply want a few pointers to help you develop your style and painting techniques, then read on. Of course, you desire inspiration and to get painting right away, so this is not a word-heavy tome that works its way through every conceivable technique, which may or may not be useful to you. Instead it shows how professional artists work and explains what drives them on, giving details of the exact paint colours and techniques used so you can learn instantly from their experience.

Obviously you will have your own ideas about what constitutes good style, and doubtless you will have a favourite painting in the book. However, do allow this book to open your mind to other possibilities. Look at the work of artists who don't paint in the way you do. Don't let it stop at simple admiration – have a go yourself, even if you think your work won't come up to the mark. It is an excellent way to improve your painting if you try to paint in the style of a skilled artist. Art schools call this 'learning from the masters' and encourage students to copy an actual painting, but I think it is more fun to pick your own subject and then adopt a specific artist's style. Ideally pick one of the artists who paints very differently from you. For example, if you work in a tight, realistic manner, it can help to loosen up and add life to your work if you try to paint more freely, preferably with larger brushes and on bigger sheets of paper. Try painting a landscape in the style of Thirza Kotzen (pages 48–57), for example, using large brushes and plenty of paint.

Most students who are fairly new to painting or who haven't had formal training have a tendency to copy Nature somewhat slavishly. Unfortunately, simply copying what you see is not enough – what you need is a style or look which is all your own

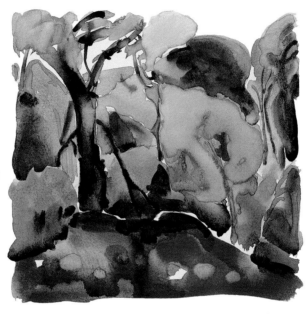

'A painter paints to unload himself of feelings and visions.'

(Pablo Picasso 1881–1973)

if you are going to make your mark as an artist. Have no fear, however, this doesn't have to involve a complete change of expression – the realistic style will always be popular with both artists and art buyers. Take a look at the flower paintings of Carol Carter (pages 82–9), for example. The flowers are realistic enough in outline but Carol has painted them in a simplified way and enhanced the colours until they look as if they have been painted on silk. At more than 100cm in each dimension, these flower paintings will light up a room like a stained-glass window.

Also take a look at the work of Marjorie Collins (pages 16–23). The precision of her work will practically bring a tear to the eye, but it is not this alone which makes her work successful. When Marjorie paints she starts with a precision drawing, but she also keeps the original subject in front of her so that she can add back in details which were lost, or continue to modify the lighting or positioning of some elements. Notice, too, how she exaggerates the contrast of light and shadow to enhance the photographic quality of her work and to make it more than just a straight copy of a scene.

To help you find your way through the maze of possibilities and stumbling blocks which face the artist, the work of each painter is considered in sections: inspiration and starting point; composition; colour and technique. The first element is a brief introduction to the chosen image and often describes what drew the artist to the subject in the first place. Surprisingly this is frequently not simply the appeal of the objects or landscape in question but more often a specific colour or colour combination or an appealing play of light and shadow. Indeed, many successful artists regard themselves as painters of light rather than subject matter.

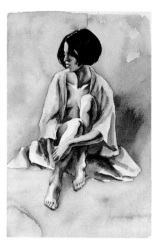

Composition

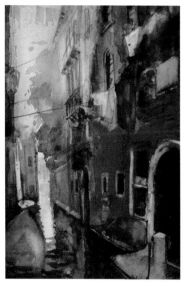

This is the second category covered for each artist and it is a difficult subject to get to grips with. In the past it was given considerable weight and importance by artists and art schools but now it is sadly overlooked and considered rather boring, with the result that there are very few sources of information. Part of the problem is that composition is often completed subconsciously or by feel so many artists would not even know where to begin when asked to describe their composition methods. They simply know what is right through experience and an inherent design skill.

However, if your paintings are lacking in impact or simply don't work and you don't know why, then you could well improve things simply by taking more time to consider composition and by learning some basic rules. These rules will give you a starting point and help you analyse what might be improved in an image. Once you have mastered them you can follow them, bend them or even ignore them altogether, but having them behind you will give you greater strength.

Composition's greatest impact is in creating mood and in leading the eye into and around the painting. Think of something that is very tranquil – an empty sea, perhaps, or a room sparsely but beautifully decorated and lit by a few candles. Why are these so tranquil? One reason is the colour –

the blue of the sea and the subdued colours created by the candlelight – but the other reason is down to composition. Horizontals and verticals are very calming while diagonals are energising (the more steeply angled they are the more energising they become). So the strong, unbending horizon where sea meets sky and the simple verticals and horizontals of a room for relaxation are conducive of calm.

Notice, too, how the lines of a composition work to pull us into or out of a painting and to keep us amused. In its simplest form artists can create a path of some description for our eyes to follow. Look at Cecil Rice's 'Canal with Washing', for example (left) where the canal acts as a path to draw us in. We are also drawn along the contours of the buildings and the washing lines, these forms helping to keep us entertained. More subtly, but no less effectively, the pattern of colour has the same effect, as our eyes jump between the white areas of

'Painting is a very difficult thing. It absorbs the whole man, body and soul.'
(Max Beckmann 1884–1950)

sunlight, stonework and washing. This shows how well colour can be used compositionally to good effect.

One of the best ways of developing your compositional skills is to examine some of your favourite paintings and identify the composition. Break it down into simple shapes – circles, triangles, squares and rectangles – and look for repeating shapes and patterns. At first you may not be able to make out the compositions of complex paintings, so start with something simple such as Lucy Parker's painting of 'Jo in Kimono' (top left). Here we can see how the figure forms one large triangle. Look more closely and you will see how this can be broken down further into two smaller triangles, one from head to elbows and the other from knees to the edges of the kimono. The overlapping of the two triangles creates a feeling of closeness, as if the girl is hugging in on herself protectively.

Now look at 'Chartier, Paris' by Trevor Chamberlain (right). Don't be scared off by all the details. Again you will see that there is a triangle, this time created by the bare floor space. Notice how this acts like a runway to lead us in, giving us the feeling that we are physically entering the café. Now look at 'Jo in Kimono' again and you will see that the triangles here work in the same way, leading us to the points of each one where the main focal points are. However, in this case the triangles are contained, intimate spaces which enclose our attention whereas in 'Chartier, Paris' the triangle is an empty space which functions like an arrow to point the way in.

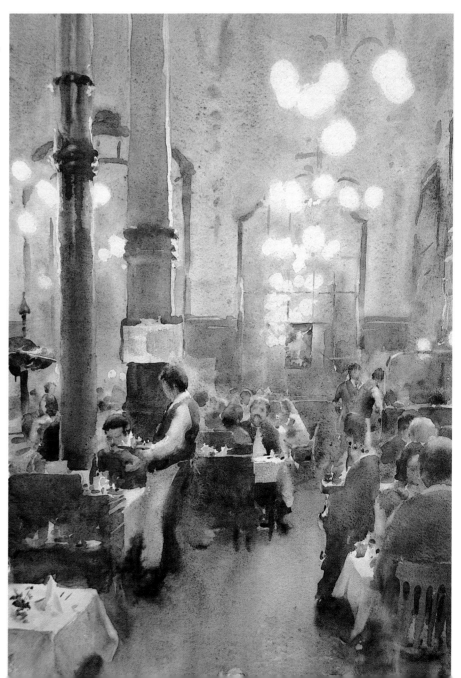

Colour

cadmium yellow

cadmium lemon

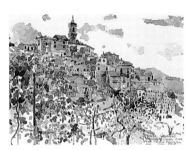

This is my personal favourite section and despite all the very best advice about the need to limit one's palette of colours, in order to attain colour harmony and true mastery over mixing, I would love to own every colour ever made. My mouth waters at the very sight of some colours and I can almost taste them in my mouth. When I saw thioindigo violet and cobalt turquoise, both of which were brought to my attention by Carol Carter, I just had to have them.

It can be surprisingly difficult to mix an exact colour until you become really familiar with your paints, so it is a sound rule that you should establish a palette and stick to it, whatever the subject, adding in a few additional colours as necessary for a particular piece or simply for fun. Katy Ellis likes to paint on the move, so she admirably limits herself to a regular palette of just six colours (pages 40–7). These colours, which comprise two reds, a green, blue, yellow and brown, are diverse enough to enable her to mix most hues. Compare this with Trevor Chamberlain's palette which is structured along the same lines (pages 58–65). Note that his chosen red, yellow and brown are all earth colours, producing mellow, harmonious images.

cad. red with lemon

cad. red with cad. yellow

cadmium red

permanent rose

raw sienna

burnt sienna

French ultramarine

Winsor blue

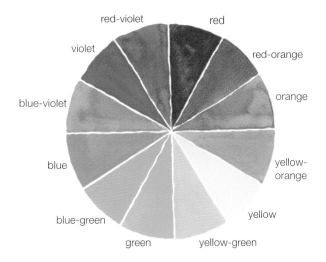

red-violet
red
violet
red-orange
blue-violet
orange
blue
yellow-orange
blue-green
yellow
green
yellow-green

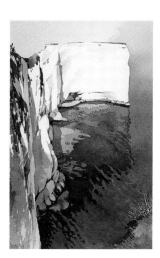

Remember that it isn't necessary – or even always desirable – to mix up the exact colours of your subject. If you make a mistake in your mixing you could see it as a happy accident, using artistic licence to 'improve' on Nature.

You may also choose to pep up reality deliberately, enriching the true colours or even changing some of them altogether. Carol Carter's enormous portraits (pages 32–9), for example, are expertly and realistically plotted, but the artist plays with the colour to turn her work into something more. The figure in 'Son', for example, would not really have purple and scarlet hair (although these colours may have shown up as reflected colour in the shadows) but they work wonderfully in the painting. In fact, the colours look so right that we may not even notice them at first.

A potential palette

If you haven't established a palette yet, you might like to try Ron Jesty's, which is shown on this page. This is a good basic palette with lots of potential for good colour mixing. If you prefer more unusual hues, remember that too many paints in a watercolour painting will make it look muddy. Carol Carter picks just six hues for each painting – aim to do the same.

Using the colour wheel

The colour wheel is traditionally used to explain colour theories and exemplify colour mixing. It isn't quite as simple as it looks, because some colours are stronger than others so the balance becomes unequal and because there isn't actually a primary red, blue or yellow watercolour paint to work from. That said, the colour wheel is a useful aid for showing the basics. You can see from the wheel, for example, that if you want to make violet you need to mix blue with red. You can refine this further by using a blue which is already leaning towards red (French ultramarine) and a red which is leaning towards blue (alizarin crimson) in the mix. Likewise, to mix a good green the colour wheel shows you that you will need a blue and a yellow. Choose a yellowish blue, such as cerulean and mix it with a bluish yellow, such as cadmium lemon.

The colour wheel also identifies the complementary very readily. The complementary colour is that which appears opposite it on the colour wheel. If you want to tone down or 'knock back' a colour, you can do this best by adding a touch of its complementary. The more you add, the closer the mix approximates to a neutral colour (brown, grey or green); the less you add, the more it resembles its parent colour. If you want to tone down yellow without changing it too much, simply add a touch of violet.

Technique

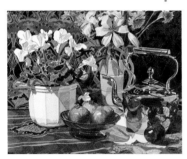

Some art books might lead you to believe that before you can begin to paint seriously with watercolour you need to learn numerous techniques and rules. Your art teacher, on the other hand, might get quite angry at such a suggestion and encourage you to throw the rule book out of the window and get painting. Who is right? Pleasantly the answer is that they are both right – you get to choose the route you want to follow. Look at how differently the artists in this book work. Some, like Thirza Kotzen know the rules but prefer to push them to the back of their minds and work freely, putting practise and inspiration first. Others, like Ron Jesty (pages 66–73) work traditionally, using expert sketches as references and painting thoughtfully and logically by starting with very pale washes and working up to darker colours.

Remember, too, that you don't have to follow where others have gone before. Peter Misson (pages 24–31), for example, has developed his own spectacular technique which involves painting the paper, washing it off, painting over it again and so on up to ten times. The result is a splendid melding of colours, sometimes dark, sometimes translucent, which is perfect for his wonderful stormy seascapes.

'I am inspired by places that feed my dreams.'
(Thirza Kotzen)

About egg tempera

This book includes work in egg tempera by Antony Williams. This is a traditional medium, and probably the most durable of all, and is made by mixing pigment with distilled water and egg yolk. As with ordinary watercolour the paint is highly translucent so work carried out initially will often show through in the final work. Painting in egg tempera is a slow and painstaking business because every stroke dries almost instantly and the paint cannot be adjusted by pushing it around on the paper. However, if you like watercolour and in particular like to work precisely, you may like to have a go.

Ideally your methods should suit your skills, personality and subject. Can't draw but are good with paint, for example? Why not adopt or modify Marjorie Collins' technique of projecting a transparency of her subject on to paper and then drawing over the lines to provide a basic framework. You may feel that this is cheating, but it is actually a well-used design technique and will not, by any means, ensure a professional-looking painting. If you don't have a projector, simply get an enlargement of a print and then trace this onto the paper. You will find that even with this as your basis, producing a convincing painting will not be easy.

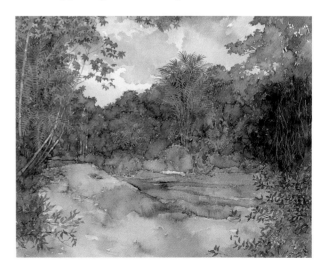

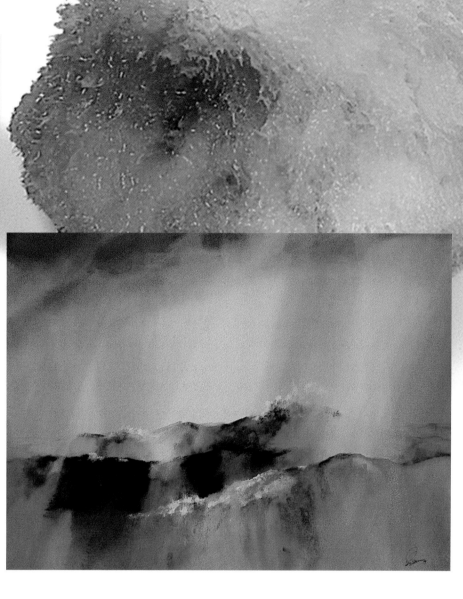

Maybe you have a different problem and can draw well but tend to make a mess of things when you start adding the paint. You could adopt a simplified style of painting like that of Katy Ellis. Her characterful drawings work wonderfully on their own and provide a superb record of travels abroad. Her painting style is very much that of a drawer, letting brush-strokes stand alone. Notice that she doesn't overpaint, but allows white space to remain if appropriate. Her mother, Shirley Felts, is also an expert drawer, and she, too, allows the precision of her hand to show in her paintings, though in a very different way (pages 98–105). Look to these artists to help you. Learn from this book, but above all remember that painting is an enjoyable and cathartic experience that should be treasured.

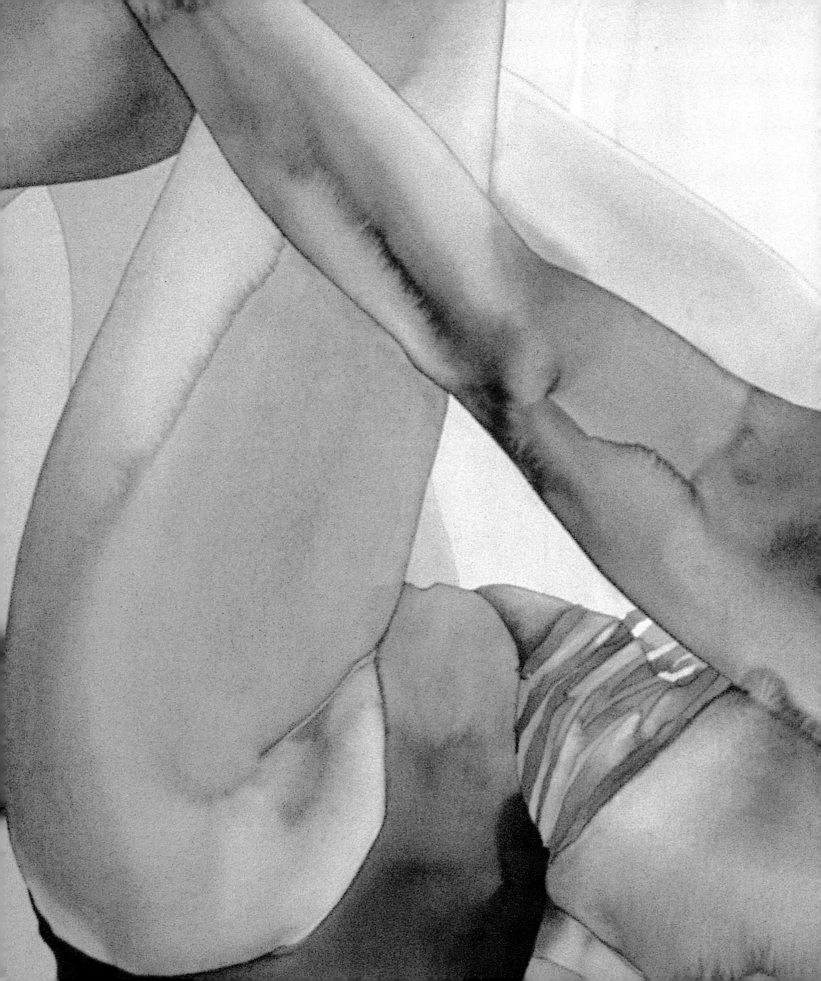

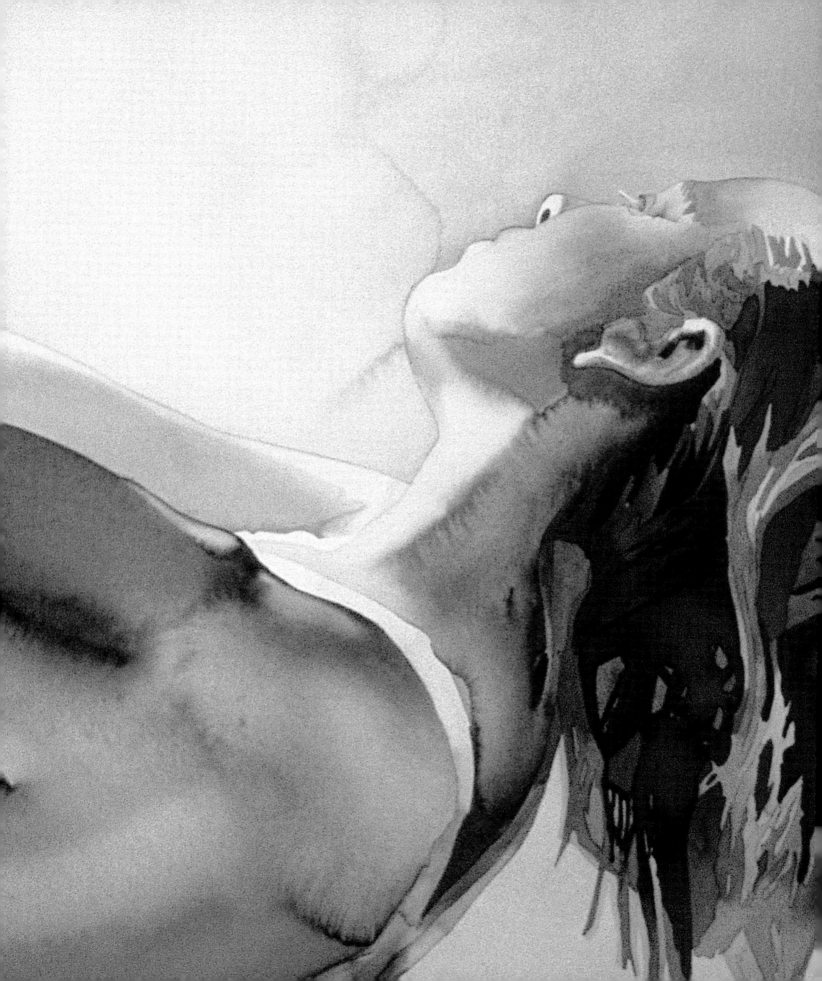

STILL LIFE WATERCOLOUR

Marjorie is a great collector of trinkets, kitchenware and other household objects found in antique shops and flea markets, 'being especially attracted to metal coffee pots, kettles and bowls', and she utilises her treasure in her paintings. She had recently bought the copper kettle featured in 'Still Life with Pomegranates' specifically for a commissioned work so when she decided to set herself a challenge with a highly complicated set-up, she thought of the kettle at once. The challenge was to include both fruit and flowers in the same painting since she had, until then, painted only one or the other, and she added a number of other materials – ceramic, fabric and metal – to make the challenge harder still.

Still Life with Pomegranates by Marjorie Collins watercolour on paper **55 x 72cm**

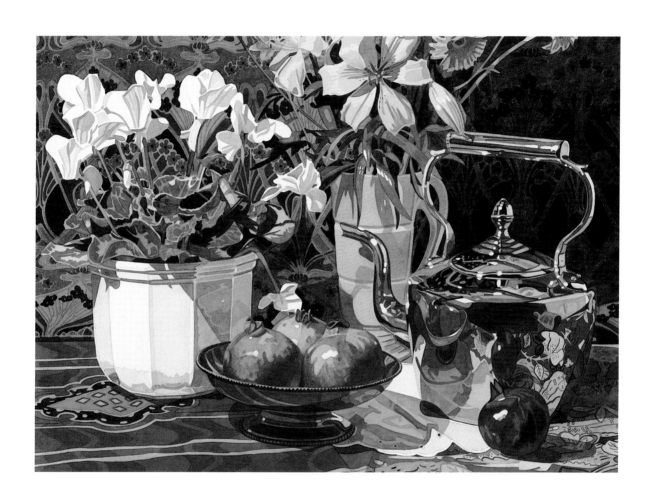

Composition

Still Life with Red Coffee Pot watercolour on paper **46 x 56cm**
Here are Marjorie's original composition photographs for this painting. As you can see, she experiments quite a bit with her set-ups, even when they are made up of just a few elements, as here. In this case she has chosen the simplest arrangement with the elements creating a basic triangle. This simple geometric shape complements the pattern on the fabric and enhances the stark, minimalist colour combination.

Once Marjorie was fairly happy with the set-up, she got out her camera to see how the arrangement would look as a finished image. 'I always view the set-up through the viewfinder of my camera in order to explore various viewpoints and compositions. Often at this point one or more objects will have to be moved in order to obtain a better reflection or shadow in the foreground area.'

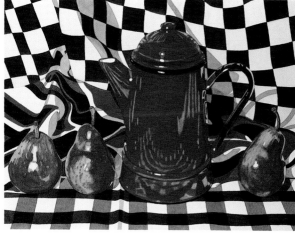

Using photographs
Marjorie is one of the few artists who makes good use of photography for her paintings. She takes a number of pictures of the set-up from various angles and distances so that she can choose the best one or combine the elements of more than one in a single composition. Sometimes she will also rearrange the elements to see if she can improve the set-up. As you will see later, she uses slide film so that she can project the best image onto the surface of her watercolour paper when drawing, although she also refers to the original set-up items while she works.

Marjorie has allowed a fairly equal border around the two sides of 'Still Life with Pomegranates' and beneath the objects but crops the yellow bouquet off at the top. The space at the sides and bottom prevents the image from seeming overcrowded – cut off this space with your hands and you'll see how the image becomes too busy, with no restful spaces. Cropping off the flowers, however, is a good move because it adds drama and creates sweeping lines which lead us into the top corners of the painting. It also reduces large, unwanted background areas on each side of the flowers.

With a complicated set-up like this it is important to create a balance of form so that the 'weight' of the items is in perfect equilibrium. Here the items are balanced around a central point – the empty space above the bowl of pomegranates. The white ceramic cachepot containing the cyclamen is fat, its colour dense and opaque, so that it takes all the weight of the copper kettle, the vase of yellow flowers and a stray pomegranate to match it, particularly because part of the yellow flowers are cropped out to reduce their bulk. Mentally move that stray pomegranate to the other side, and see how the picture unbalances.

Notice the emphasis on soothing, rounded forms in this painting which help to make this a relaxing image despite its complexity. The bowl, jug, cachepot and kettle are all rounded, and even the lilies appear round when seen from front-on. Only the shell-shaped cyclamen flowers break the mould to offer a welcome change of form. They are still curvy, even voluptuously elegant, in keeping with the rounded forms elsewhere.

golden rule

Balancing forms

All items and even blank spaces have a visual weight which must be balanced to create a pleasing composition. Opaque, hot colours have a greater 'weight' than transparent, cool ones so a cadmium red boat can be balanced against a whole sea of manganese blue. For still life artists this means arranging and rearranging the items in the set-up until they look right, or rebalancing the items in the painting by making colours stronger and more opaque or cooler and paler until equilibrium is reached.

Colour

Marjorie's highly representational way of painting demands accuracy in the rendition of colour as well as form. 'I choose the objects for the set-up with an eye to their respective colours and how they relate to one another, so once they are in place I paint them as they are, without the need to enhance or mute. I do, however, have a tendency to prefer objects and fabrics that are brightly coloured and which contrast with one another.'

The artist's palette

Marjorie used a palette of 14 Winsor & Newton colours for this painting: aureolin, new gamboge, yellow ochre, cadmium orange, burnt sienna, alizarin crimson, mauve, French ultramarine, cobalt blue, sap green, Hooker's green dark, Vandyke brown, sepia and lamp black. Black is an unusual choice because it can deaden colour, but Marjorie likes to tint it with French ultramarine for pattern detail. She also favours a mix of French ultramarine and mauve for shadows.

aureolin

burnt sienna

pointer

Black is back

Many artists and art teachers have dismissed black, saying that it dirties the other colours or simply isn't a colour at all. It is true that it is difficult to handle and can overwhelm a painting when used neat or heavily in mixes, but a little can be useful for muting and darkening other colours. It is also a highly traditional colour – probably the one first used by cave painters – and it has had great importance in Chinese art for thousands of years. More and more artists seem to be adopting it, and provided that you don't use it simply as a convenient way to produce any dark colour, there's no reason why you shouldn't try it too.

Vandyke brown

sepia

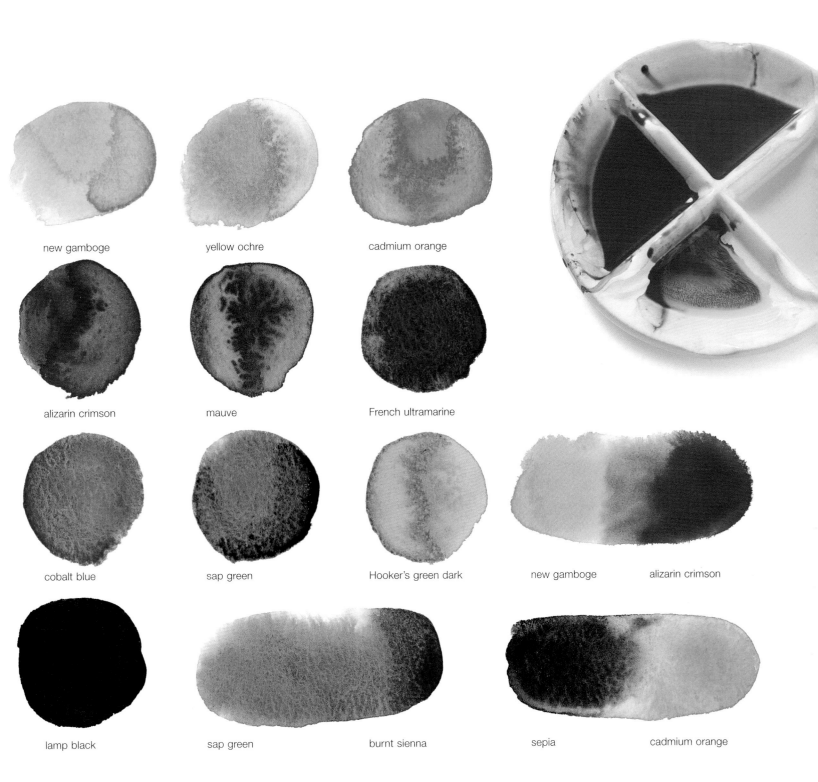

new gamboge

yellow ochre

cadmium orange

alizarin crimson

mauve

French ultramarine

cobalt blue

sap green

Hooker's green dark

new gamboge alizarin crimson

lamp black

sap green

burnt sienna

sepia cadmium orange

Technique

'I start by projecting the chosen slide(s) of my set-up onto heavy cold pressed Not watercolour paper, correcting or changing the shapes of objects as I draw. While painting, I refer to the slide and have the actual objects in front of me, although not the original set-up. I replace deteriorating fruit and flowers as necessary.

'I paint all the shadows with a mixture of mauve and French ultramarine in order to establish tonal patterns. Then, working wet-on-dry, I glaze thin layers of local colour onto the background areas, starting at the back and then working forward until all the objects appear as negative shapes. Against this background I am better able to judge the correct colours of the main objects, so I continue by painting layers of local colour over each object in turn, being especially careful to paint around the white highlights of the white cachepot, the cyclamen flowers, pomegranates and kettle.

'I always paint an object, such as a single pomegranate first, before painting its reflection, in this case on the side of the copper kettle. Once all the reflections are painted, I analyse the remaining reflected shapes, changing them if necessary to make sure that they all make sense. Finally I check to make sure that the background recedes sufficiently. In this case I glazed in another shadow wash over the background area and intensified patterns in the fabric where necessary.'

'Paint only the differences between things.'
(Henri Matisse 1869–1954)

shortcuts

Starting with local colour

Local colour simply refers to the colour of an object – the exact yellow of a lily petal as seen in good light – but as all artists know, you'd be left with a very stylised image if you painted every petal on the lily and every part of every petal in the same colour. In real life each petal of that flower is seen as a multitude of hues and tones because of reflected colour, shadows and so on. Marjorie starts by applying a thin wash of each item's local colour, then builds it up from there, adding warm or cool layers of colour and introducing shadows and reflections as necessary. This is an excellent way of working, but remember to leave the lightest areas blank if necessary to prevent having to add highlights back in with Chinese white.

Even the background areas are rendered with great care and attention – this fabric is clearly recognisable as a Liberty print. To make sure that the pattern of the fabric did not compete with the main objects, Marjorie washed over it with a thin wash of Vandyke brown and her shadow mix of mauve and French ultramarine, toning it down and pushing it into the background.

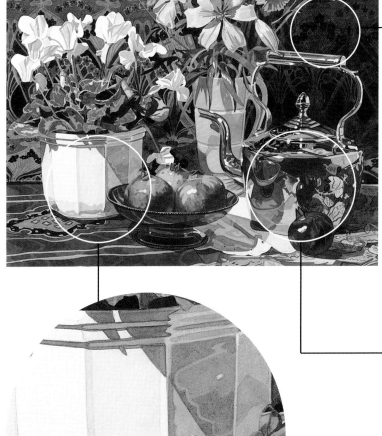

It can be very difficult to render white in a painting because it is important to give the object shape, but too heavy a hand with the washes will make it look grey. Marjorie has added her shadows with a restrained hand but made good use of some strong, dark shadows around the lip of the pot which help the white of the ceramic look whiter by comparison.

Marjorie renders the subject with great accuracy and we are rewarded with a visual treat, particularly with the intricate patterns and colours of the reflections. This is a time-consuming process, and a detailed painting like this usually takes Marjorie several weeks to complete.

SEASCAPES WATERCOLOUR

Peter Misson has the sea in his blood. His great-grandfather was a sea captain and several of his family were at sea, so it was no surprise that he took to it also and now has his Master Mariner's Certificate. 'I have experienced at first hand the vastness, majesty and power of the ocean. I have felt her breath under me and seen her serenity that often follows her anger. This has been my life and my inspiration.'

Yet despite his love and knowledge of the sea, he says 'the weather and light are the real subjects of my work. I want to convey a feeling of being there rather than give an accurate record of any place.' This desire is resonant of the artistic aims of the great JMW Turner (1775–1851), 'a master of atmospheric watercolour', whose work Peter much admires.

Gale Breaking Biscay by Peter Misson watercolour on paper **72 x 54cm**

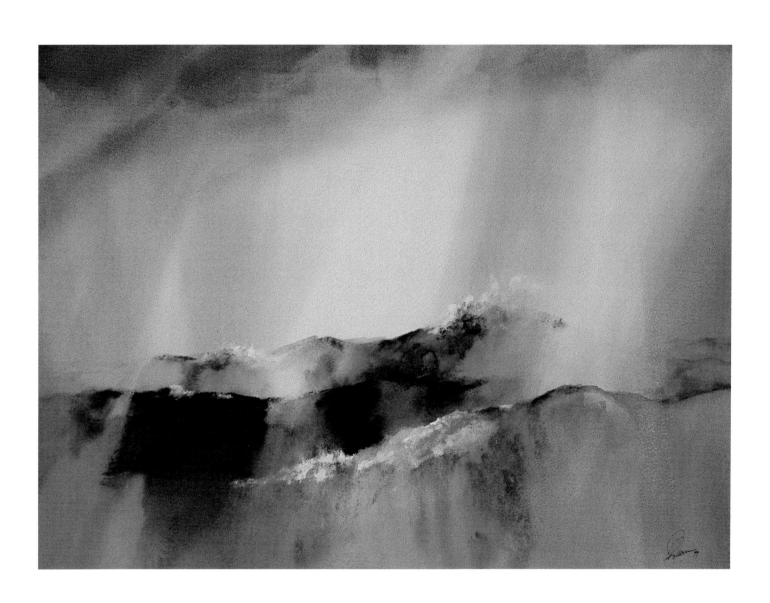

Composition

Sketching from life can be a tricky business at the best of times, but on a boat with its constant movement and with the buffeting wind and sea spray it can be even more problematic, so one might expect the artist to use photographic references. However, Peter spurns this option. 'Most of my seascapes are worked from pencil sketches made at sea, often on very small pieces of paper (I never use photographs).'

As a mariner Peter is drawn to features which are particularly interesting to seamen. 'Mostly I include something important to a mariner – a lighthouse or headland, for example. Indeed, lighthouses have recently become a bit of a theme in my work, especially rock lights – lighthouses on remote rocks, often in very hostile places – such as Bishop's Rock in the Scillies, the Wolf Rock or Eddystone off Plymouth.

'I work in the studio from my thumbnail sketches. The pictures seem to compose themselves when they work and I can switch off my brain and just let the memory flow. I can't really explain, but I push the paint about and I'm at sea. I think it was Degas who said that only when he no longer knows what he is doing does the painter do good things.'

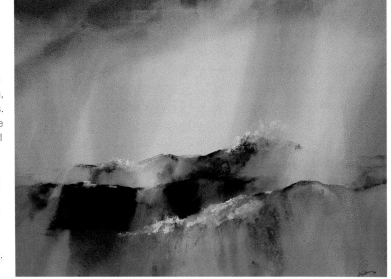

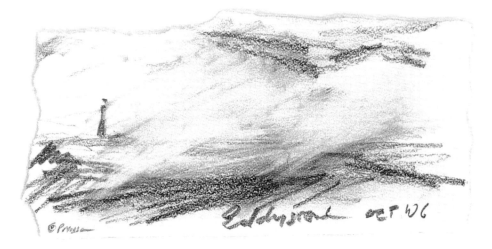

These actual-size examples of Peter's sketches show how small he often works when on board his boat. Although the pencil sketch of Eddystone Rock is obviously brief (left), it's laden with atmosphere and the more detailed watercolour sketches have clearly caught the spirit of the sea (right).

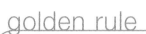

Peter draws attention to the diagonal crest of the nearest wave by highlighting it in white and setting it against the inky darkness of the wave behind (see Golden Rule). By giving this diagonal more weight he infuses the image with greater energy because we feel the power as our eyes race along it.

Most seascapes are composed so that the sea fills the lower third of the picture area and the sky takes up the remainder. By dividing the support more or less in half Peter gives emphasis to the tremendous height of the waves – it is as if they have reached up from the lower section to take their place in the middle.

The furthest wave echoes the shape of the nearest one to reinforce the power of the diagonal. It stops short of the edge of the support so our eyes tumble over the end and we seem to feel the tremendous drop that follows the upward push of the wave, sensing the swell and fall of the sea.

golden rule

Counter-change

Dark tones set against light ones or light ones set against dark always catch the eye and can infuse a painting with energy. To emphasise or draw attention to a specific area of an image artists often deliberately heighten the contrast, a technique either known as counter-change, reciprocal tone, alternating contrast or induced contrast. They can also use this technique if a painting seems dull overall, heightening the contrasts generally to give it more sizzle. However, Peter didn't need to exaggerate the tones in his painting because the reflective qualities of water and the dramatic lighting of a storm combine to produce the most incredible natural contrasts.

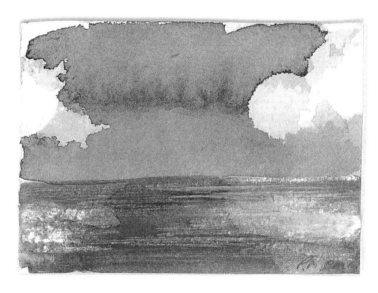

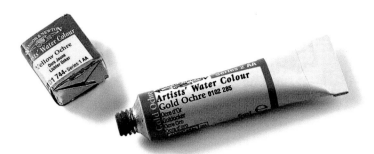

'Every glance is a glance for study.'
(JMW Turner 1775–1851)

Colour

'"What colours do I use?" is quite a difficult question for me to answer. You may as well ask "What colour is the wind? What colour is light or the thrill of being at sea in a breeze?" I am always amazed at the colours that appear in the sky at sea. You somehow never seem to see quite the same on land. The spray certainly helps, a sort of salt breeze hanging over the sea, especially with some wind, and that heightens the colour of the water.'

The artist's palette
Peter uses Winsor & Newton watercolours, choosing from both the artists' range and the cheaper Cotman range. He always tries to use the colours as they appear in Nature, never inventing them for effect. Although his palette varies he avoids green as much as possible and only mixes it himself, never using a tube green because he considers these rather nasty. In general his palette revolves around the primaries – red, yellow and blue. 'I always let the colours mix on the paper, using only colours straight from the tube and primaries that will keep the watercolour from becoming muddy. I use lots of water and lots of pigment.'

Gwenap Head watercolour on paper
50 x 31cm
'This is the first point to round after Land's End. There was a big swell at Gwenap Head so we could ease the helm and begin to run to Falmouth.' Notice the dramatic contrasts here, again ranging from the inky blue of the sea to the white of the spray. This time there is more colour in the sky, a rather sinister orange, which is reflected briefly in the sea. The landscape, depicted in a muted grey, has fewer contrasts and therefore has less importance in the composition, but it is strong enough so that it stays at the back of our minds, as doubtless it does for the passing mariners who cannot be allowed to forget the dangers posed by the rocks.

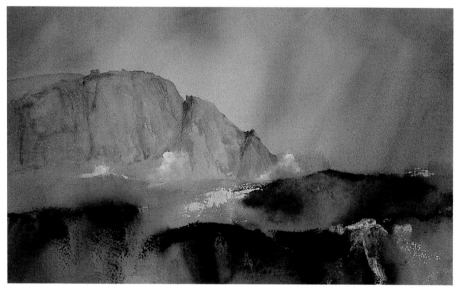

raw sienna cobalt blue

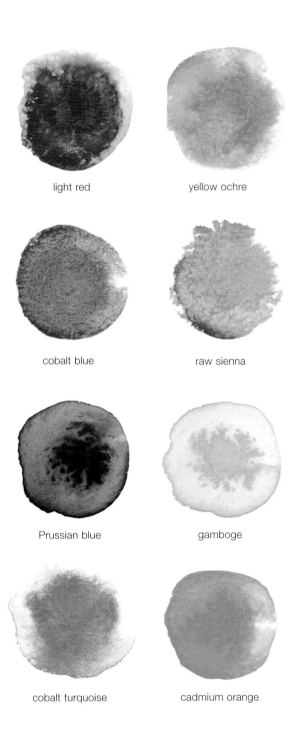

light red yellow ochre

cobalt blue raw sienna

Prussian blue gamboge

cobalt turquoise cadmium orange

gamboge cadmium orange

gamboge light red

pointer

About greens

Peter is not alone among artists in preferring to mix his own greens rather than buying them ready-made and there is good reason for this. For a start one can mix a good range of greens from blues and yellows, so why go to the expense of buying the colour specially? Also mixing ones own greens is a good exercise in using colour and should be encouraged. Additionally greens seem to fall into three categories: weak mixing colours, very strong ones and unreliable ones. Cobalt green and terre verte are very weak and rarely hold their own in a mix while viridian and phthalo green are incredibly strong and can overwhelm other colours. Olive green, sap green and Hooker's green vary depending on the brand, and although some good ones are around you have to be careful because there are also many which will fade or dull over time. If you do wish to invest in a green choose chromium oxide green which is a good mid green or select one of the strong colours – viridian or phthalo green – and use them with care.

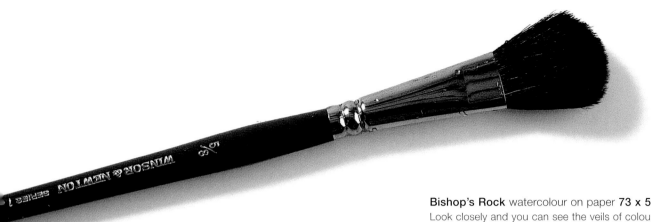

Technique

'My technique has evolved over the years; a way of washing off and painting on and washing off that seems to add depth to the work. Turner used to plunge his work into tubs of water and work very wet. I've developed a similar technique. The ghost of the colour seems to stay after it has mostly been washed off and I build colour layer on layer until it's done. Most of my paintings take anything from five to ten washings, being thoroughly dried in between and I apply the paint sometimes on wet paper, sometimes on dry. I push the paint about and the image just seems to happen. Watercolours like this are a little like a crash landing; practise and knowledge sometimes let you take risks and get away with it.'

Bishop's Rock watercolour on paper **73 x 54cm**
Look closely and you can see the veils of colour here which have been built up by applying paint and then washing most of it off. Colour applied layer upon layer produces the wonderfully deep dark tones in the water while fewer layers give the sky its translucency. The textural effects produced by this process add to the appeal of the finished work.

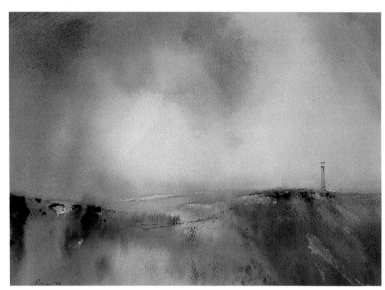

shortcuts

Washing off
Peter's technique of applying paint and then washing it off is not as straightforward as it might seem. Different watercolour paints have different staining properties so while some may wash away to leave just the faintest hint of colour others will stain the paper quite dramatically. You obviously need to have a good idea of how much the paper will be affected before you apply a particular colour. Experimentation is the key, but you can also refer to the paint manufacturer's descriptions to give you a head start. In the Winsor & Newton artists' range, for example, you'll find that Winsor blue and Prussian blue are both staining while cobalt will fade to just a hint of colour. Nearly all of the reds tend to stain as does cadmium yellow and about 50 per cent of the browns.

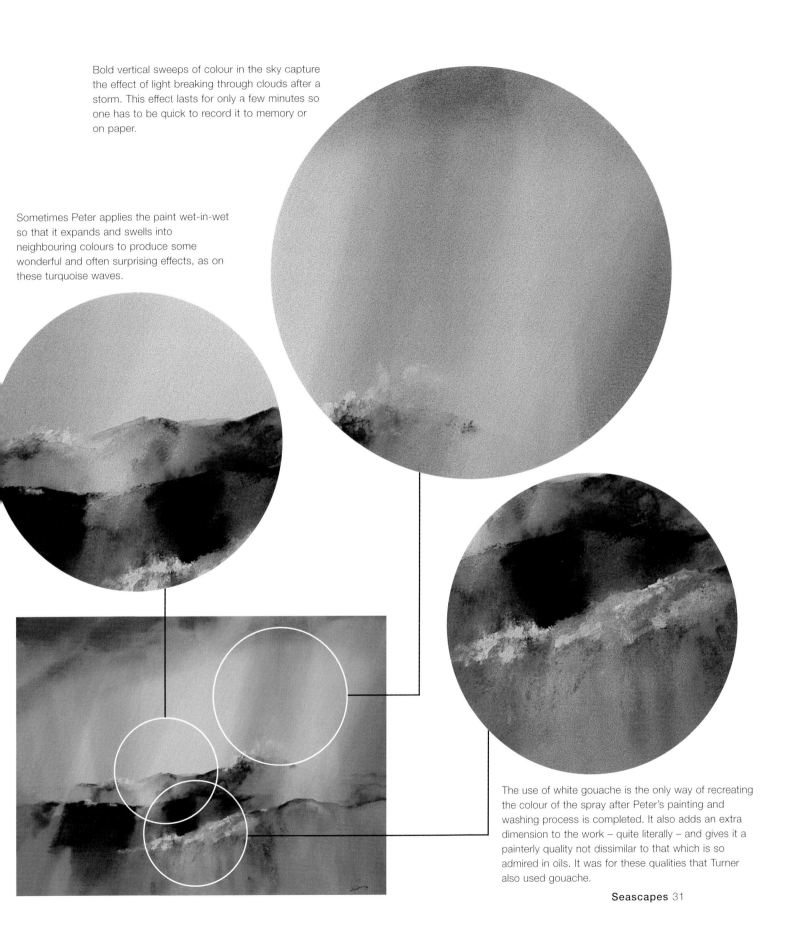

Bold vertical sweeps of colour in the sky capture the effect of light breaking through clouds after a storm. This effect lasts for only a few minutes so one has to be quick to record it to memory or on paper.

Sometimes Peter applies the paint wet-in-wet so that it expands and swells into neighbouring colours to produce some wonderful and often surprising effects, as on these turquoise waves.

The use of white gouache is the only way of recreating the colour of the spray after Peter's painting and washing process is completed. It also adds an extra dimension to the work – quite literally – and gives it a painterly quality not dissimilar to that which is so admired in oils. It was for these qualities that Turner also used gouache.

'My work is autobiographical in nature.'

'Having grown up in Florida, my strongest visual impression of an environment for human activity is water. In much of my work, water, either literal or suggested, provides the setting for anonymous figures. Because the figures are abstracted, they become generic: their generic nature allows for expansion of the narrative beyond a personal, anecdotal statement to portray a more universal human condition.

'I like to work with the female figure because it illustrates the message I want to convey. I choose poses that reflect genuine human postures and I am usually the model, although I do paint other figures.'

Son by Carol Carter watercolour on paper **76 x 102cm**

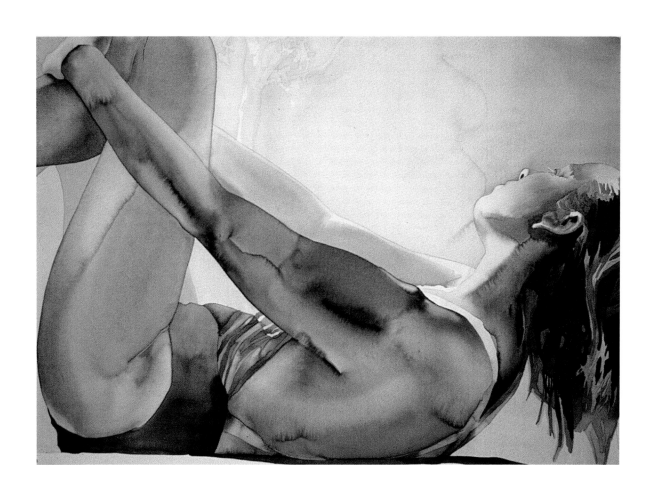

Composition

'For me, painting should have an intimacy, a mysteriousness, a sensuality. At its best, my work also has an edge; something in it that takes a moment, a second look, an effort to comprehend.' Looking at 'Son', you'll see that the three elements of intimacy, mystery and sensuality are all put into play. The composition brings us in close to the woman and her relaxed pose creates intimacy. The mystery is created by the woman's face being turned away and by the questions the picture provokes: who is she, where is she and what is she doing? Sensuality is provided by the pose, arms wrapped around the knees and neck pulled back, and by the application of paint which captures the silky bloom of skin while still being painterly.

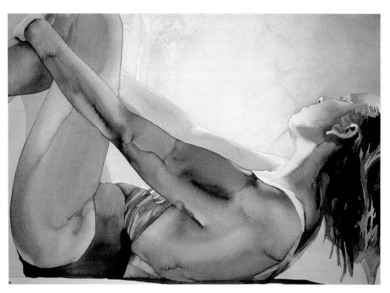

Using herself as a model, Carol works from photographic references. 'I take most of my own reference photography but I have also hired other photographers to document me. I work in a series. I explore many different viewpoints and usually take the strongest idea to completion. I usually frame things in a dynamic way so that the subject is obvious and noticeable. The large scale of the watercolours is also confrontational and the resulting images are seductive, powerful and strangely disquieting.'

Sunset watercolour on paper **74 x 105.5cm**

In 'Sunset', Carol uses lashings of cadmium scarlet on the woman's head to help suggest the intensity of the light from which she is shading her eyes. The blue and blue-green shadows on the woman's arms, being split complementaries, help to intensify the colour and make it sing.

This striking and unusual composition hangs on the strong diagonal of the woman's arms which leads us down from the top of the support with force and speed.

The triangle in composition has strength and stability as you can see here. In this composition there are three main triangles formed by the figure's body, her raised head and the negative space between the top of her body and the top of the support.

A number of smaller triangles subdivide the main compositional triangles, creating a series of zigzags which help to give the painting its energy and vigour.

golden rule

Dramatic diagonals

In composition, horizontals and verticals produce a calm feel while slanting angles create energy and movement; the sharper the angle, the more energy it contains. In this painting angles push up in different directions, some steeply, some at a recline, creating an exciting conflict between the restful movements and the forceful ones. This struggle between opposites is something Carol aims to maintain in all her work.

Colour

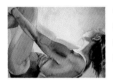

'My paintings contain duality: clarity and ambiguity, sanctuary and threat, pleasure and pain. The use of vibrant, saturated colours – beautiful, but confrontational in their intensity – contributes to the tension between these extremes.'

The artist's palette

'I use principally Winsor & Newton watercolours and I have a limited palette – typically I do a full painting with only four to six colours. The limited palette allows for the painting to be consistent. There are several pigments that I'm very comfortable with: French ultramarine blue, Winsor violet, and Indian yellow, for example.' The samples on this page show the full range of colours

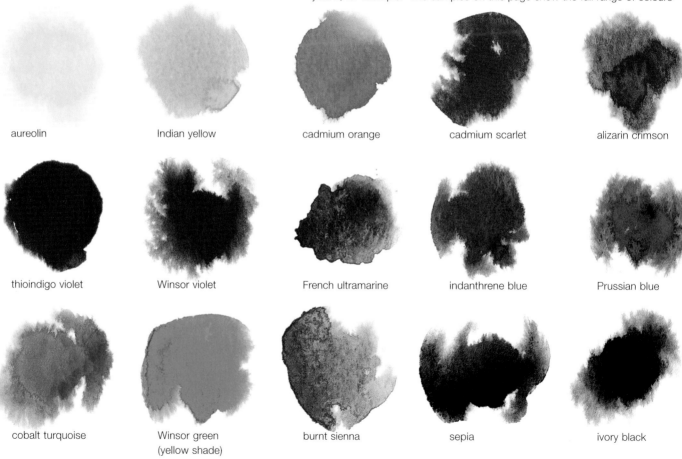

| aureolin | Indian yellow | cadmium orange | cadmium scarlet | alizarin crimson |

| thioindigo violet | Winsor violet | French ultramarine | indanthrene blue | Prussian blue |

| cobalt turquoise | Winsor green (yellow shade) | burnt sienna | sepia | ivory black |

'The chief aim of colour should be to serve expression as well as possible.'

(Henri Matisse 1869–1954)

which Carol might select from when embarking on a painting. The blues, greens and violets are all useful for depicting the water which is a constant theme in her paintings, while 'I just use ivory black and Prussian blue for my nude watercolours. I don't use the black, preferring to mix the blacks: from sepia and Prussian blue, for example.'

French ultramarine alizarin crimson

Indian yellow thioindigo violet

aureolin cobalt turquoise

pointer

About Indian yellow
The first paint called Indian yellow was made by force-feeding cows on mango leaves and denying them water. The resulting concentrated urine of these poor beasts was collected and mixed with mud and then later purified to make the paint. Today Indian yellow is a general title given to a variety of yellows of varying qualities. The Winsor & Newton version which Carol uses is permanent and fairly transparent.

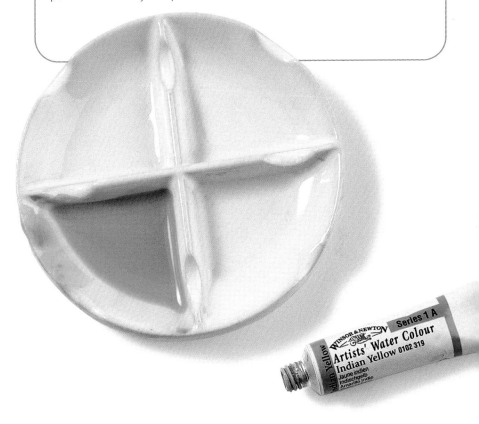

Technique

Carol works from a photograph or combination of photographs, laying out her paper flat on the floor 'to allow the paint to puddle'. Her favourite tools are 'round, pointed watercolour brushes (Kolinsky sable) and flat wash brushes for large areas.' Everything is about the balance of opposites, so sometimes she applies the paint lightly, in very wet washes to create the sort of soft colour we see on the figure's torso, and in other areas she applies it vigorously to create the energy of the hair and costume, for example.

The right conditions

Carol finds that the weather in Florida is perfect for her style of painting because of the humidity. 'The air is humid and moist, and it rains almost every day during the "rainy season". I really like to paint when it's raining, because the moisture in the air allows the wash to dry slowly, and I get more time to manipulate the colour and flow.'

shortcuts

Creating a bloom

More often than not blooms or back-runs occur accidentally or as a by-product of an artist's style of painting. To produce one deliberately the artist must apply a wash of colour and allow it to dry slightly until it is damp, rather than wet. Then a second wash of colour is applied. This flows into the first wash, sweeping some of the pigment from the first wash with it to create the distinctive pattern. If clear water is applied over a damp wash it creates a very pale bloom.

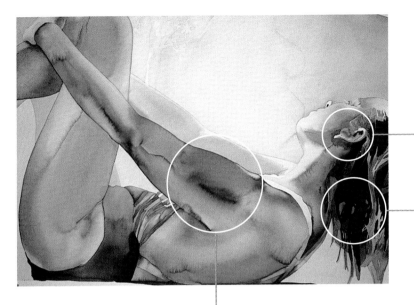

Leaving small flecks of white showing helps capture the sparkle of reflected light and enables Carol to retain the airy feel we associate with watercolour.

By applying wash upon wash of intense colour Carol is able to achieve a vibrancy and depth of colour which we might usually associate with acrylic or oil rather than watercolour. This intensity is balanced by the quieter areas of the painting where colour is applied with a lighter touch.

This rich effect is called a bloom or back-run and happens when one wash is flooded into another, drier wash. The second wash displaces some of the first and as it dries it creates a strong rim of colour at the edge with a crinkled shape like a flower petal. It takes a lot of practise to create this effect deliberately and with the desired intensity.

LANDSCAPES WATERCOLOUR

'I was on my way to Rome via Abruzzo where I wanted to explore the mountains, but without a car I was stuck in a hostel beside a lake. Luckily, there was a small hill town just two miles away and I loved the steep narrow streets, the odour of damp stone and the glimpses of bright geraniums in the windows. I spent a day painting this, just below the town, sitting on a chair brought to me by a local lady. I finished it just as the sky darkened and it began to rain.'

Bomba, Abruzzo by Katy Ellis watercolour on paper **30 x 38cm**

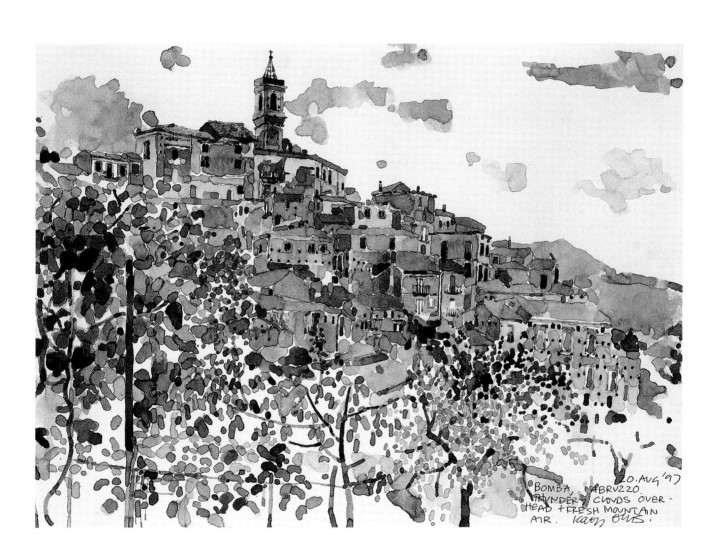

20. AUG '97
BOMBA, ABRUZZO.
THUNDERY CLOUDS OVER-
HEAD & FRESH MOUNTAIN
AIR. KAEN OLUS.

Composition

Katy took her time finding the best possible viewpoint to enable her to reveal the character of this hill-top town and at the same time produce a balanced image. From here the weathered houses, clustered closely around the steep, narrow streets look as if they are built on top of one another. 'I walked all round searching for a good view before deciding that this was the most dramatic. Looking up from below with the hint of mountains in the background it looked most impressive.'

The dramatic diagonal of the hillside on the right-hand side, with its dense covering of houses, leads the eye forcefully up to the focal spire. On the left, the gentle slope also draws the eye but at a more leisurely pace. Even the tree trunks in the foreground seem to point towards the spire.

Katy positioned the focal church spire roughly a third of the way over from the left-hand side – a position usually considered most pleasing in a painting.

The town fills the page almost to bursting, as if the top of the spire and the edges of the town are reaching out to the edges of their domain. This makes the town seem far more imposing than if Katy had allowed more of the background to encroach on the scene.

golden rule

Cropping for drama

Katy's town exactly fills the space available, making the best use of the picture area and showing the truth of the phrase that 'what you leave out is as important as what you keep in'. Sometimes it's possible to create even more impact – and add life and movement to a painting – by actually cropping out part of the subject, a technique favoured by Impressionist Edgar Degas (1834–1917) and also used by Claude Monet (1840–1926). This can add to the intimacy of a scene or make the subject seem so powerful and impressive that it has burst beyond the onlooker's field of view.

Katy's sketchbook is like a journal, with sketches accompanied by written descriptions of the atmosphere, her mood, what she was doing at the time and sometimes also describing the colours. Her written notes are invaluable, helping her recall the true sense of the place and her reaction to it when she comes to make a painting.

alizarin crimson	cadmium red	sap green	ultramarine

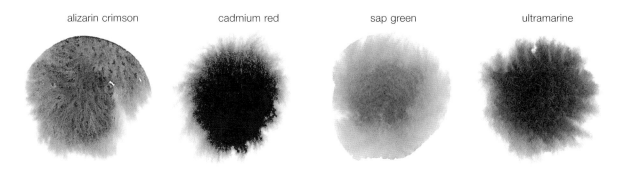

Colour

Katy tends to paint on the move, so it makes good sense for her to use a limited palette. This cuts down on the amount of equipment she has to carry, although she sometimes needs to take good stocks as fresh supplies are not always readily available. A limited palette is also an advantage because it makes it easier to get to know the colours thoroughly and cuts down on time wasted trying to mix a particular shade or hue using unfamiliar colours.

Katy also uses limited equipment – a No. 4 series 7 Winsor & Newton sable brush and 150lb hot-pressed Saunders watercolour paper. She transports her watercolours and drawings in a large plastic tube which she can carry on her shoulder, and stores her watercolours, brushes, pens and charcoal in a lightweight container.

The artist's palette

Katy favours pale colours in her limited palette, often using sepia, sap green, cadmium yellow, cadmium red, alizarin crimson and ultramarine. Sepia and ultramarine provide the darkest tones, ensuring that there are no harsh notes in her paintings and she has chosen two reds, one warm and opaque, the other cool and transparent to give her maximum versatility. Because it had rained the day before this painting was made, colours – and smells – were stronger, so Katy overlaid washes to produce the depth of tone needed.

ultramarine	cadmium yellow

alizarin crimson	ultramarine

pointer

Hues, tones, tints and shades

Although these terms are often used indiscriminately as synonyms for 'colour', each has its own distinct meaning. Hue means the same as colour, but tone refers to a colour's lightness or darkness – how it would look in a black-and-white photograph. A tint is a colour which has been lightened, while a shade is a colour which has been darkened; both refer to a colour's tone. The phrase 'shades of night' uses 'shade' correctly, because it refers to tones darkened by night.

sepia	cadmium yellow

sepia cadmium yellow

Consider cadmium yellow

There are many forms of cadmium yellow and all of them are excellent when a good brand is chosen. Cadmium yellow light is strong, bright, clean and opaque and is lightfast except in humid conditions, and the darker versions – cadmium yellow medium and cadmium yellow deep – have the same excellent qualities because they are all based on the same pigments. This also applies to cadmium lemon, a cooler, greener version. Look for the pigment PY35 or PY37 to be sure you have the genuine article. Cadmium is considered toxic, but provided you don't have the habit of sucking your brushes to shape them and use them as they are intended, this shouldn't be a problem.

'When you go out to paint, try to forget what objects you have before you: a tree, a house, a field or whatever. Merely think, here is a little square of blue, here an oblong of pink, here a streak of yellow, and paint it just as it looks to you.'
(Claude Monet 1840–1926)

Technique

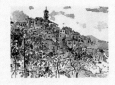

When painting on site, as Katy does, it's not possible to use all the techniques available to the artist due to limited supplies (sometimes including water) and the general inconveniences of painting outside, such as battling with the forces of wind, intense heat or rain. However, through skilled handling Katy manages to use a variety of techniques to give added life to her paintings, including using a dry brush and working with pools of colour.

shortcuts

Working wet-on-dry

This term doesn't simply mean applying wet paint to dry paper. It refers to the classic watercolour technique of painting in layers, allowing the existing washes to dry before applying the next one, thus gradually building up to darker, richer areas of colour. The danger with this technique is knowing when to stop – it's easy to overwork a painting, dulling the colours by applying too many paint layers and blocking out the white of the paper.

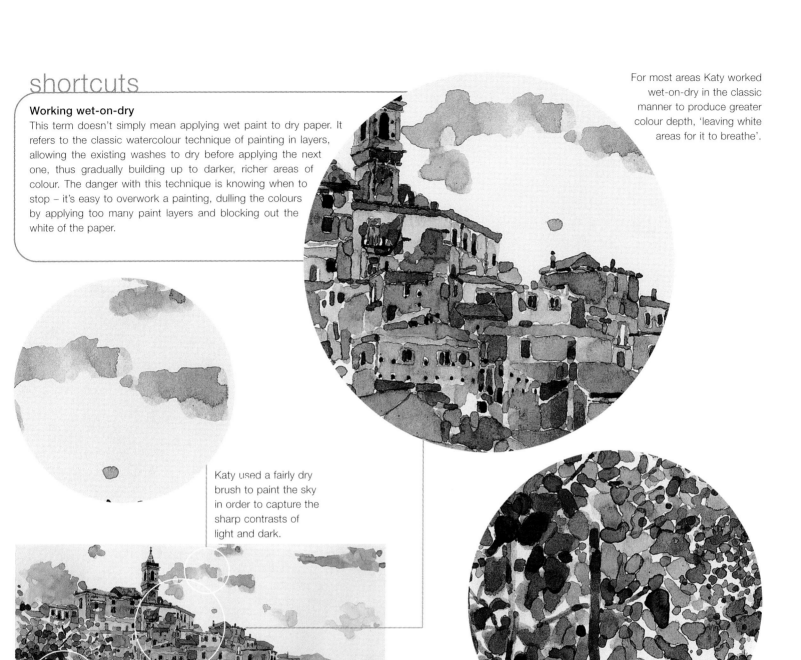

For most areas Katy worked wet-on-dry in the classic manner to produce greater colour depth, 'leaving white areas for it to breathe'.

Katy used a fairly dry brush to paint the sky in order to capture the sharp contrasts of light and dark.

By allowing the paint to form small puddles on the paper Katy was able to create deep areas of colour which dried in all sorts of ways, adding variety and colour in the foreground tree canopies.

LANDSCAPES WATERCOLOUR

'I am inspired by places that feed my dreams.'

'Landscape is my language. I am drawn to places that take my breath away. Not always the grandest vistas or the highest peaks, but the configuration of forms and shapes, colours, detail and movement that compel me to paint. I am inspired by places that feed my dreams, that awaken my memories, and which remind me that I was born in Africa.

'I hear music when I sit in or pass through a place and know that this comes from some deep well inside me. I hear whole symphonies, a musical notation of the rhythm of life, with all the density, repetition and quiet pauses, with all the drama and routine. I am influenced by the Mozart I love and the Heavy Metal I'm not sure of. I am influenced by the poetry I read for pleasure and the news I read in pain. I absorb most of the art that I see and am affected by it whatever its emphasis.

'Landscape is an incredible language. It is infinite, always teaching me new things about myself and my relationship with the world. It stimulates in me an awareness and appreciation of the sacredness found in the moment and in the place.'

Rochas 13.5 by Thirza Kotzen watercolour on paper **21 x 21cm**

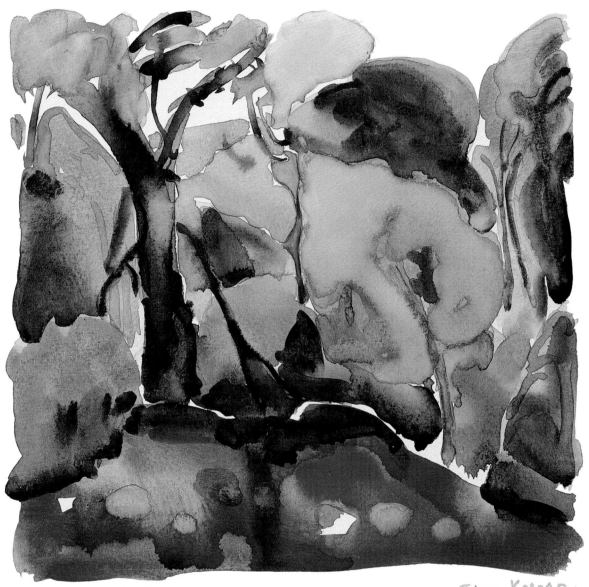

Rochas 13.5.97 Thirza Kotzen.

Composition

'I am constantly aware when I am painting that the image I am creating is two-dimensional, not a "photographic" interpretation of what I see. It is important therefore to stress the elements that capture the feelings I want to express and this may involve exaggeration, distortion and always a strength of design that acknowledges the format. The geometry of a composition is essential to make the painting work.'

The square format, giving as much space vertically as horizontally, encourages the eye to rove about the picture plane in circular motions, keeping the viewer ever interested.

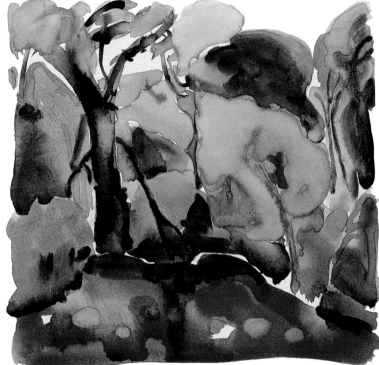

Rochas 13.5.97 Thirza Kotzan.

'"Rochas 13.5" is not about a journey. It is about the magic of place that seems to be inanimate, but actually breathes with a sense of ages past. Here it is important to hold the viewer with the coherence of the moment. I came upon this place with its monumental, ancient rocks, the seasonal trees and the blood-red earth worked by man, and felt an overwhelming sense of integration and harmony. I capture this by using a square format so that one moves slowly around and around its centrifugal composition.'

Notice how our eyes are drawn by recurring colours such as the acidic lime green and lush viridian. This helps to ensure our continued interest as well as helping to create colour harmony and balance.

It might be easy to read a long horizontal format in the same way as a book, from left to right. To prevent the viewer's attention from passing through and then out of her painting, Thirza applies colour so it dances between and among the trees, drawing the viewer in and holding their attention.

'"In 'River II" I have heightened the colour to enhance the sense of warmth and light and rhythm of the place. I have removed unimportant details and concentrated on the "journey", the feeling of movement and the sense of time as one moves along the river. To do this I have used an elongated horizontal format. To prevent the viewer from travelling from left to right and then out of the picture, I have allowed recurring space to glow between the trees.'

golden rule

Square formats
Most artists choose to paint landscapes on a 'landscape' format – that is a picture area that is wider than it is high. This not only gives maximum space to the landscape but it also conforms to our field of view which is a wide oval. The square format is rarely used but it is preferred by some artists (and photographers) because it creates a balanced image and reminds us that this is art and not simply an imitation of Nature.

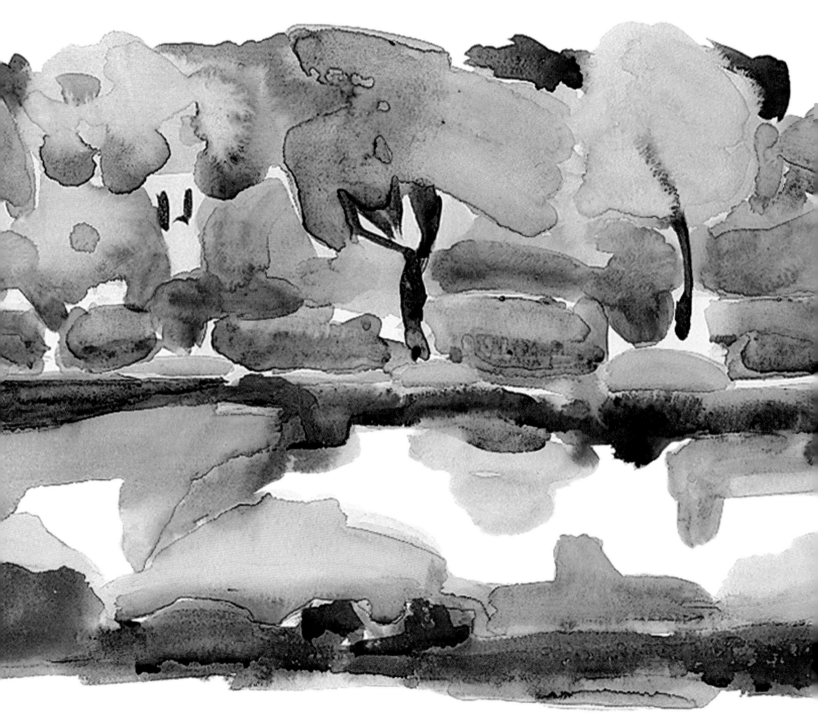

Colour

'I have often been asked about my use of colour and cannot truthfully say how or why I use it. It is that part of me that comes from deep within and has a force that is both mysterious and intangible. It is the most emotional part of my creativity and I greatly value my intuitive sense about it. I intensify what I paint with the power of colour and this gives my work its cohesion and its distinctive look.'

The artist's palette

'I use the best-quality materials that I can afford to buy. The purer the pigment, the more expensive the paint. I use Winsor & Newton and Old Holland watercolours and Old Holland and Rembrandt (which is very creamy) oil paint. I use a lot of ultramarine and lemon yellow and cadmium red and madders, and for the darks I always use Payne's grey, seldom black. Black can be too deadening.'

lemon yellow rose madder

rose madder ultramarine

lemon yellow cadmium red

ultramarine lemon yellow

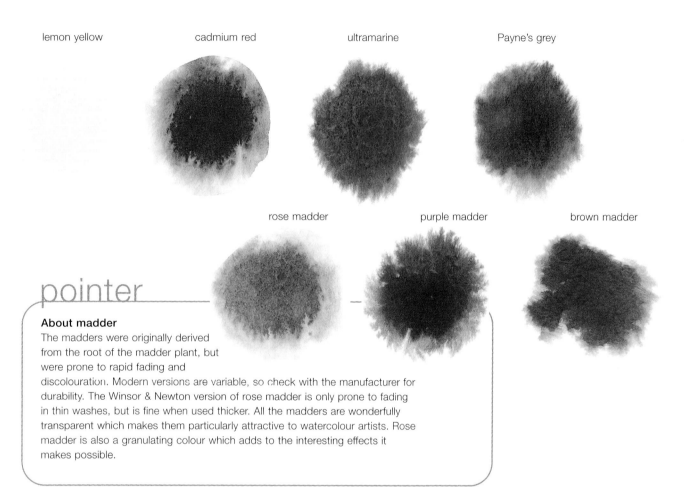

lemon yellow cadmium red ultramarine Payne's grey

rose madder purple madder brown madder

pointer

About madder
The madders were originally derived
from the root of the madder plant, but
were prone to rapid fading and
discolouration. Modern versions are variable, so check with the manufacturer for
durability. The Winsor & Newton version of rose madder is only prone to fading
in thin washes, but is fine when used thicker. All the madders are wonderfully
transparent which makes them particularly attractive to watercolour artists. Rose
madder is also a granulating colour which adds to the interesting effects it
makes possible.

Technique

'I feel that technique is important but unless it is the subject matter of the work it should not be over-emphasised. Proficiency comes from long-term seeing and doing. If too much stress is placed on technique the viewer is often left unmoved by the work, albeit admiring of it. I endeavour in my paintings not to straighten out their vulnerability with correctness. It is crucial to me that the viewer senses the creator, the person behind the work.

'I do not cultivate the use of any special techniques though I am sure the way I work is unique. I regard my method of painting as the means to achieve the expression and the impact that I want and it may be as simple or as complicated as necessary. In both my watercolours and oil paintings layers of paint are built up then broken down repetitively until the desired balance is attained. I am ever mindful of great artists like Picasso who achieved maximum impact and sensitivity often by the simplest means.'

Thirza applies the paint rapidly, letting intuition and feeling influence the painting process so that the paint recreates her joy and delight at the scene.

shortcuts

Painting with feeling

Painting with the heart often involves pushing learnt conventions to the back of the artist's mind. But experience is never totally abandoned. Knowledge of colour balance and composition is allowed to work subconsciously to ensure an effective image, while the artist urgently responds to the view, the feel of the paint and the movement of the brush on the paper.

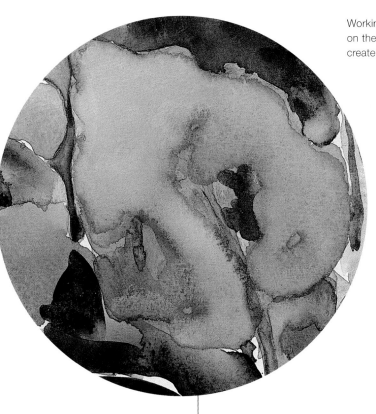

Working wet-in-wet, Thirza lets colours flow on the paper, spreading and mingling to create imaginative shapes and fresh colours.

'It is crucial to me that the viewer senses the creator, the person behind the work.'

Rochas 13.5.97 Thirza Kotgan.

By leaving white spaces between areas of colour, Thirza allows the painting to breathe and prevents the strong colours she uses from becoming overpowering.

'A typically French restaurant, probably unchanged since Monet's day.'

Trevor had contemplated painting this busy café for a while before finally making his decision to go ahead. It is the sort of place where the Parisians go, not just the tourists, and at the end of the meal the waiters write out the bill on your tablecloth. 'I had visited this restaurant several times in the past and longed to paint it but I was put off by the impossibility of tackling such a busy subject. Usually I work directly on site, but the viewpoint I favoured was right inside the main entrance – people queuing, coming and going – so I couldn't even make a thumbnail sketch. In the end, unusually for me, I took a photograph of the scene to record scale and proportions and then relied largely on my memory and the impression the place had made.'

Chartier, Paris by Trevor Chamberlain watercolour on paper 53 x 36cm

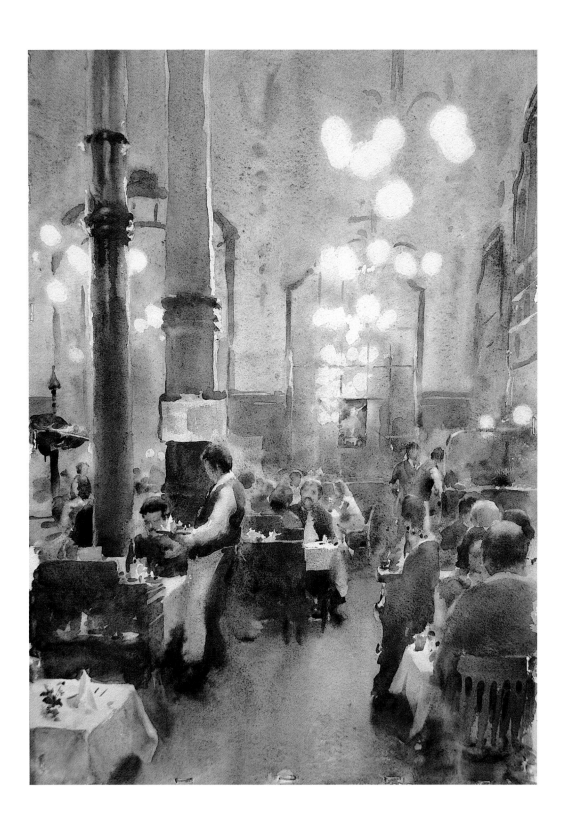

Composition

'Apart from the general layout and architectural features, the finished painting is not a slavish copy of the photograph but owes much more to my vision and interpretation: I wanted to portray the general ambience of the place. Using a portrait format I positioned the two columns to the left of centre, with the main subject – the waiter on the left – at the base. This waiter was invented and positioned by my imagination. He is given prominence by being surrounded by the darkest tones.

'The ceiling lights were an important feature, as were their reflections in the huge mirrors, all tending to lead the eye towards the main waiter. I simplified colours and details and only included things which contributed to the image as a whole. White tablecloths give additional punctuation.'

Trevor usually works from sketches, like this one (above) showing the waiter in his final position.

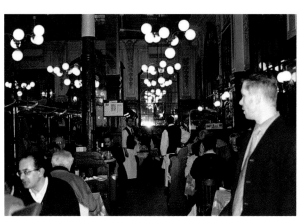

This is Trevor's reference photograph (left). It provides a record of the basic layout and features of the restaurant, but Trevor has avoided the trap of copying it exactly, without thinking of the composition. He has repositioned the waiters and some of the clients to create a stronger image – by 'removing' the waiters cluttering up the gangway, for example, he creates an open passageway which helps to lead our eyes deeper into the painting.

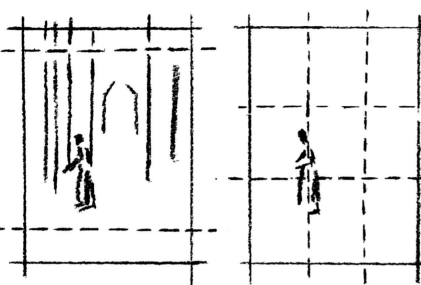

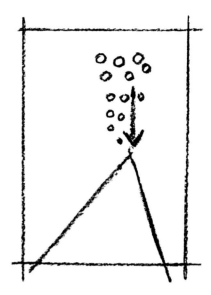

The vertical format helps to give the restaurant a more intimate feel by closing off the sides and calls attention to the elegance of the room and the height of the columns.

The main focus of the picture – the waiter at the base of the columns – is positioned in what is considered one of the key locations in a painting, where the lines which divide the support into thirds both horizontally and vertically intersect.

The pale area of bare floor and the trail of white lights hanging from the ceiling lead us deep into the painting. Other white areas then catch our attention so that our eyes are kept constantly roving about the painting, never tiring, always interested.

golden rule

'Reading' a format

Most people read a support in a particular way: from left to right and back again when looking at a landscape format; from bottom to top and down again when looking at an upright (portrait) format; and in circling motions at a square format. Artists can build on this by placing visual pathways for the viewers to follow that trace this natural progression – the contours of a reclining figure in a landscape format or a circle of recurring colour in a square format, for example. Trevor leads us deep into the restaurant by clearing the gangway between the tables so that we follow it from the bottom to the middle of the support. Then he directs us once more as our eyes naturally sweep down again by leading us along the line of lights. Because the main focal point lies outside this pathway, it distracts us and encourages our eyes to look elsewhere, seeking out every detail in this busy place.

'All that is not useful in the picture is detrimental.'

(Henri Matisse 1869–1954)

Colour

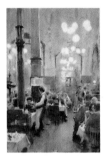

Trevor uses a limited palette with a heavy bias towards earth colours – raw sienna, burnt sienna, Venetian red and burnt umber – to create lovely soft paintings, glowing with life and light. To these colours he adds one red, one blue and one green, adding other colours occasionally when there is a particular need. In this painting he aimed for 'an overall well-balanced colour harmony reflecting the interior's warm, faded grandeur.'

The artist's palette

'I use paints by Winsor & Newton, Rowney and Talens, choosing raw sienna, burnt sienna and Venetian red by Winsor & Newton, permanent magenta, French ultramarine and burnt umber by Rowney and viridian by Talens. I always avoid strident colours – Prussian blue and Winsor blue, for instance – and black. However, I sometimes use cadmium red, yellow and orange for accents here and there.' To create his dark tones he likes to mix French ultramarine with burnt umber or burnt sienna, modifying them to give a cool or warm hue.

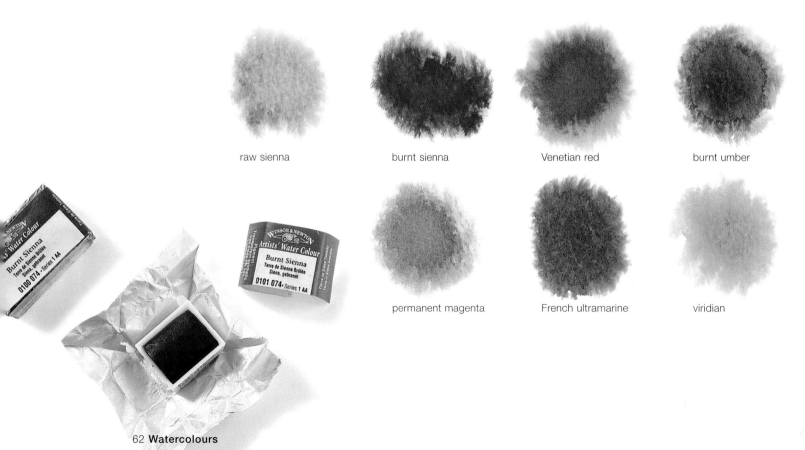

raw sienna burnt sienna Venetian red burnt umber

permanent magenta French ultramarine viridian

raw sienna Venetian red

French ultramarine burnt umber

French ultramarine permanent magenta

French ultramarine burnt sienna

pointer

Colour harmony

There are several ways of ensuring colour harmony in a painting. A good way for beginners is to use a very limited palette of, say, six colours, mixing them into each other or using a deliberately dirty brush to produce a wide range of related hues. Another good option is to choose several colours from specific paint families since these are likely to combine well. These include the earth colours, which Trevor favours, the cadmiums (yellow, orange and red) and the madders (purple, rose and brown).

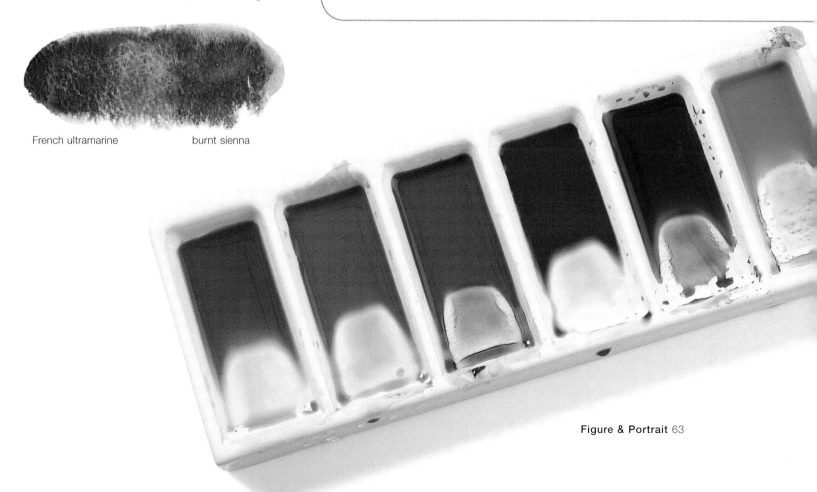

Technique

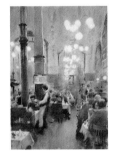

'This was painted in the studio using stretched, moderately rough 140lb paper. I started by sketching the scene with a 2B pencil, depicting figures taken from the photograph and from sketches done at various times and locations. I masked out the ceiling lights and certain other highlights so I could apply the first washes freely on top. For these I first dampened the paper with a sponge, then applied the colour with a No.14 sable brush or French polisher's mop.

'I leave this "ghost" image to dry and then work in a more finished way, adding darks, lifting out lights, drawing with a pigment-loaded brush and maintaining soft edges where I want them. In this case I was anxious to convey the scene in a lively, impressionistic manner, with passages of sharp definition complementing areas merged wet-in-wet.'

Masking fluid

There are two types of masking fluid: a clear, colourless variety which is designed to avoid staining, and a lightly tinted version which is easy for the artist to see on the paper. Both are usually applied at the start of the painting process to protect the whites and highlights until a later stage. They are made from rubber latex which sticks to the paper and repels the water and pigment. Both should be applied with a brush, but since they are difficult to remove completely from the bristles, an old brush is best reserved for this process. The dried latex should be removed from the paper within 24 hours by gentle rubbing, after which it becomes very difficult to budge.

shortcuts

Exploiting contrast

Contrast can help to draw attention to an area of a painting or inject it with energy and life. In figurative paintings these contrasts often exist already, but the artist can play them up or down to call attention to a feature or to make it less significant. Trevor is a master of this technique, placing light colours against dark, dark against light and juxtaposing warm and cool colours so that we are continually drawn to look at his work.

'Sound underlying drawing is fundamental in this work but I don't allow the result to be too tight and static.'

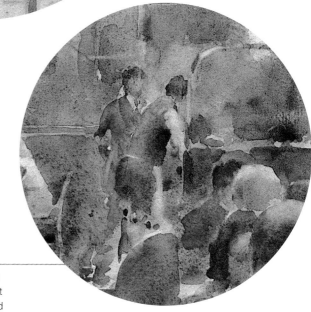

A fine brush enabled Trevor to add a few details which help to complete the scene, such as the wine bottle on the table and the items on the waiter's tray.

Masking fluid protected the white of the paper for the ceiling lights and other highlights until the end of the painting process so that the other washes could be applied freely.

By applying paint wet-in-wet, Trevor was able to develop a free and lively style that recalls the work of the Impressionists and captures the dim, smoky atmosphere of the restaurant. This really could be a painting from another era.

SEASCAPES WATERCOLOUR

'Walking out to the headland at Studland there is no suggestion of the dramatic scenes which are to come; so it is a breathtaking surprise when one first sees the white slabs of chalk, brilliant in the sunshine and rising vertically out of the water. For thousands of years the sea has scoured the cliffs to form inlets, promontories and isolated stacks which stand in the water off-shore.

'On many occasions I have sat on the grassy edges to sketch in pencil, ink or watercolour and to take photographs. The painting of "Old Harry Rocks" is a response to the impact made on me by the brilliance of the afternoon sun on the white cliff face contrasting with the dark, dark blue of the sea 200 feet below me. Two small figures perched precariously on the cliff top give a sense of scale, vertigo and insecurity. The whole scene, to me, is one of grandeur and excitement, dramatically lit – and a ready-made composition.'

Old Harry Rocks by Ron Jesty watercolour on paper **34 x 51cm**

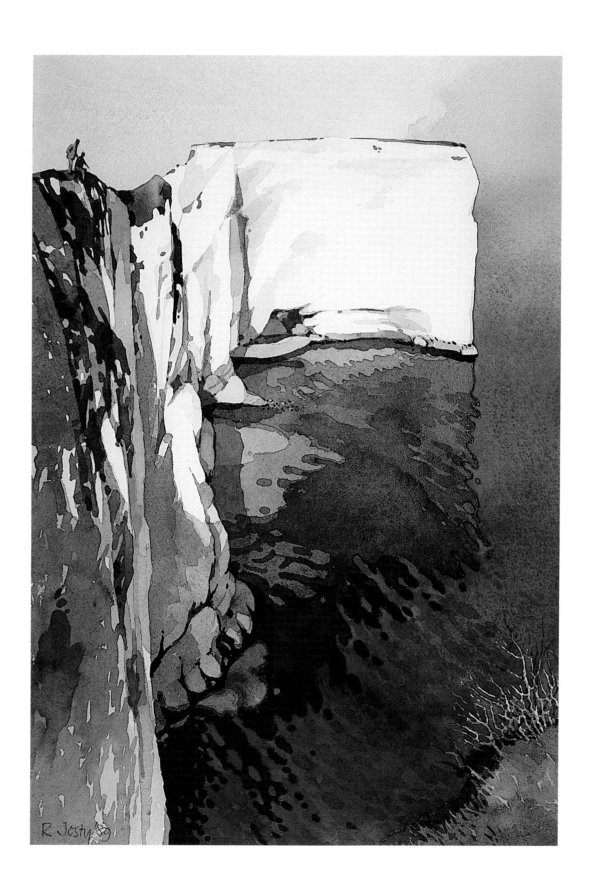

R. Josty '89

Composition

Ron's experience as a graphic designer helped him produce distinctive compositions, leading him 'to seek out orderly arrangements of shapes, tones and colour, often with an underlying geometric structure.' His compositions are often based on the balance of contrasts – 'light against dark; large areas against patterns of small shapes; warm colours against cool; opposing colours.' The sea is an excellent 'feeding ground' for an artist desiring this type of subject since the bright light and reflections from the water produce wonderful contrasts, while there is a huge variety of topography too.

 'For "Old Harry Rocks" I found a design of rectangles formed by the cliff face in the shape of its warm reflection below and the blue sea in the foreground. These are supported by the vertical cliffs at the left and the narrow strip of sea at the right.'

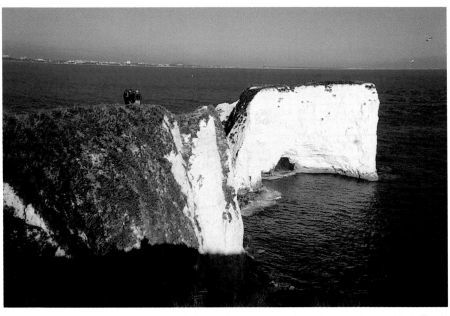

This photograph of Old Harry Rocks shows how realistic Ron's painting is in terms of topography but also how much better it is than a photograph at capturing the grandeur, height and drama of the scene. The photograph leaves the cliff face looking sadly flat and dull.

golden rule

Working with rectangles
Rectangles are solid, sturdy forms which tend to give an image a sense of balance and stability. They can be a little too static, however, and without other influences this could produce a rather 'dead' finish. To counterbalance these effects Ron has imbued his painting with movement, created by the drop from the cliff top to the sea and by the sweep of the rock as it reaches out. The struggle between the immovability of the rectangles and the energy of our eye movements produces the sense of overbalance which keeps us on our toes.

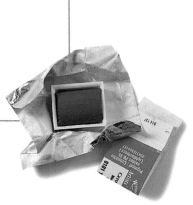

'In any painting I do, I must first be excited, thrilled or charmed by some special quality in the subject. Usually it will be something quite simple – a special kind of colour, a glint of light on the water or a feeling of drama or atmosphere in the weather. Often the "spark" is realised simply by making a little sketch (below), when the mental concentration and intense observation will reveal the special "something" which had not been noticed before.'

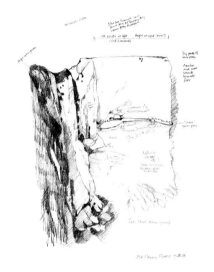

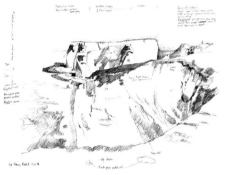

Focal points are placed to ensure that there is something going on in all areas of the picture. This draws us round and keeps us fascinated. Notice, for example, the two figures which lead us down to the sea, then round to the cave, and on to the bush in the bottom right.

Our eyes sweep back and forth on a diagonal between the two ends of the cliff at bottom left and top right. This tugs against the strong verticals of the cliff walls and creates a strong sense of movement which makes us feel unnerved and unstable, balanced as we are so high above the sea.

Ron broke down the scene in front of him into a series of rectangles. These strong forms give the painting great power and stability and help to convey the immense weight and monumental presence of the rocks.

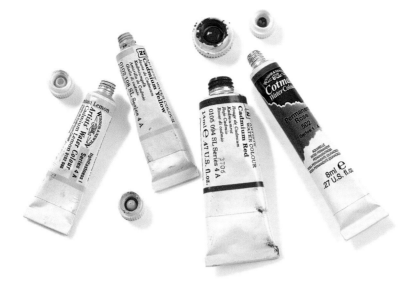

Colour

Ron tends to paint colours as they are. However, he also often paints from sketches in his studio, so the colours he uses are as he remembers them or as noted in his sketches – perhaps heightened versions of the real thing because of the emotions the scene has aroused. Like many good artists he also sees colours where other people might see a blank grey or brown. This makes for some wonderful combinations in the shadows of the white rock.

Notice the lavish use of colour in this sketch of Bull Point, North Devon (right). The rocks range from pink to violet and green as they catch and reflect the light.

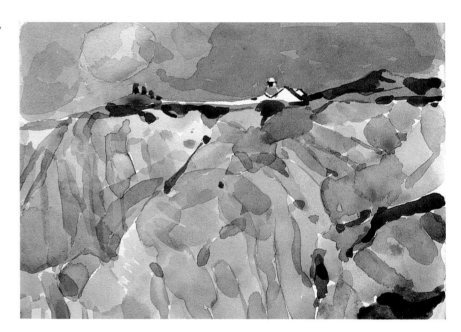

| lemon yellow | Winsor blue | French ultramarine | burnt sienna | cadmium red | French ultramarine |

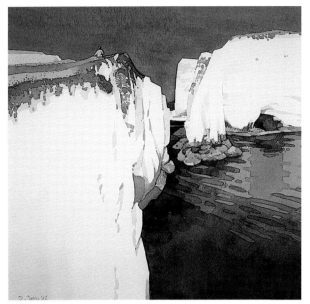

Handfast Point watercolour on paper **46 x 46cm**
A quick glance at this painting might not leave you thinking about the colour, but just as much effort goes into colour mixing where there are limited hues as it does where there is an explosion of colour. Look at how Ron has tinted the violet shadows on the side of the cliff and created the different tones in the water. They look so natural that we hardly notice them but we would certainly see the jarring note if he got them wrong.

cadmium yellow

cadmium lemon

The artist's palette

Ron has worked with Winsor & Newton artists' quality paints for many years. 'They are of a smooth consistency and an intense strength of hue which is invaluable when mixing and laying large washes of strong colour.' Ron works with an excellent palette which provides warm and cool versions of each primary plus two earth colours and from these he can mix almost any other colour. His palette comprises warm cadmium red, cadmium yellow and French ultramarine balanced by cool permanent rose, cadmium lemon and Winsor blue plus raw and burnt sienna. Occasionally he will also introduce other hues if needed such as cerulean blue, viridian green or permanent magenta.

Ron's colours all provide good lightfastness and other excellent qualities. The cadmiums, for example, are strong, clean, opaque traditional colours which mix well together and with other hues. You only need a little to go a long way. Winsor blue is another fine choice. It is a modern colour, also sold as phthalocyanine or phthalo blue, which is clean and intense. It is transparent, making it a wonderful choice for water, but it stains the paper so mistakes cannot be easily rectified.

French ultramarine

Winsor blue

cadmium red

permanent rose

raw sienna

burnt sienna

cad. red with lemon

cad. red with cad. yellow

'The work of the master reeks not of the sweat of the brow – suggests no effort – and is finished from its beginning.'

(James Abbott McNeill Whistler 1834–1903)

Technique

Ron painted the pictures shown in this book in his studio, using sketches as his references. 'Using this method affords infinite time for thought and consideration. On the other hand, conditions change quickly when working out of doors so that, usually, only a broad statement is possible, though with greater spontaneity.

'Essentially my way of painting in watercolour is quite simple and, to some extent, has become "standardised" after much practise. It consists of laying quite wet, flat washes onto dry paper stretched on a board which is horizontal or nearly so. However, when the need arises I will use graduated washes within defined shapes. Weak washes of colour are usually laid first to establish the general pattern of the composition and allowed to dry. Increasingly stronger washes are then laid over these, each being allowed to dry in turn until finally the darkest accents are added.

'I have no qualms or hang-ups about laying several washes over each other provided that those beneath are not disturbed and that colours are compatible. Rich colours and tonal effects can result in this way, as seen in the sea in "Old Harry Rocks", for example.'

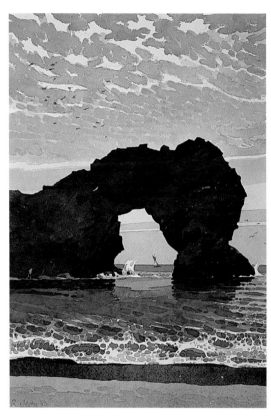

Durdle Door watercolour on paper
Ron doesn't favour masking fluid because it leaves a rather harsh, unnatural outline which he finds obtrusive. Instead he reserves white areas by drawing around them with the point of a wet brush. He did this for the surf breaking the shore in this painting which works very well.

pointer

Graduated wash
Sometimes Ron uses a graduated wash in his paintings which is simply a wash that shifts in tone from dark to light. It is quite hard to achieve a good, smooth graduated wash but it is a useful technique for creating a realistic sky, for example. Start by laying in a line of paint in a fairly strong mix then add water to the paint and stroke in another line of paint below it. Keep going, adding more and more water to each stroke of the wash so it gets lighter every time. Never be tempted to go back and fiddle with what you have done because your brushmarks will show and you will only make things worse.

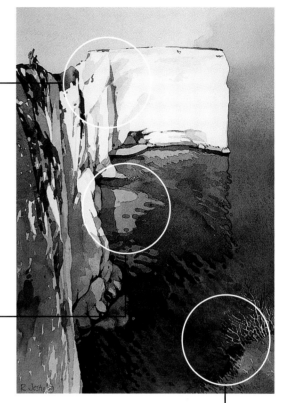

Painting white objects, such as these cliffs can be a difficult task. Ron makes them look whiter by applying some dark washes along the top and bottom with a range of tones in-between to suggest the undulating, fissured surface.

Ron reserved the white of this bush by outlining it first with a wet brush. This creates a softer look than would have been achieved with masking fluid. Notice how sometimes the branches vanish and then reappear just as they would in real life as the light and shadow play on them.

Ron applies washes layer on layer to build up the depth of colour required for the shadows in the water. This creates attractive colour variations and also helps to convey the increasing water depth.

FIGURE&PORTRAIT WATERCOLOUR

'I find life drawing fascinating and have always done it. In fact, although I started out by getting a degree in biology, I think that looking at all those natural forms was merely a substitute for art – you can't keep a good artist down. After university I applied to the local art college and did a foundation course which was huge fun. Then I went on to study illustration at Brighton, England. I couldn't complete the course because the fees were too high and luckily the opportunity to work as an illustrator came up. This was very good training and I am now very disciplined in my painting.

'I now go to an ancient art club in Brighton called the Sussex County Arts Club where I run a session in portraiture and life drawing. We have a large pool of models to draw upon. With the portrait class I am always looking for interesting people to draw, often asking them in the street if they would like to pose. I have been working on a long-running project trying to catch the look of young people today. The more tattoos, nose rings and dreadlocks they have the better.'

Jo in Kimono by Lucy Parker watercolour on paper **60 x 40cm**

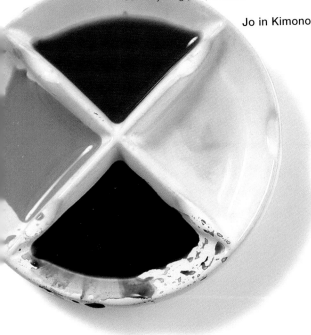

'I treat life drawing as my artistic aerobics.'

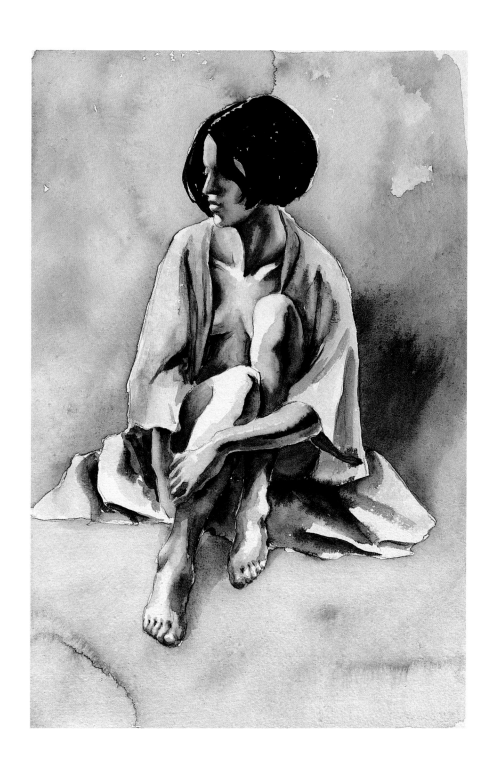

Composition

'With my life paintings, like "Jo in Kimono", I generally use sketches from my life class and pick out the best to work up into paintings. This one was a bit more controlled than most of my life paintings because Jo is such a lovely model so I wanted to capture her likeness as well. Recently, though, I have been painting directly from life. These paintings are generally done quickly to maintain the spontaneity – ten or 15 minutes at most – and I have a sketchbook full of these.'

In the end Lucy chose this pose from among her many sketches of Jo. It is based on a triangle – a solid, stable form which imparts a sense of calm and tranquillity. Triangles can produce a rather static look, but because Jo's legs break the shape and her head is turned to one side to upset the symmetry it is also very much alive. The combination of triangular composition and relaxed pose makes for a very peaceful image, easy to contemplate for hours.

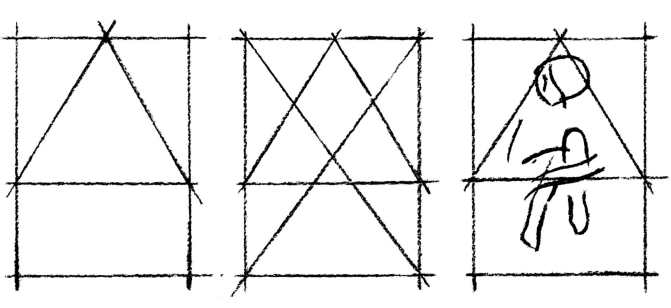

This simple but effective composition is based on an equilateral triangle which brings strength, stability, dignity and a sense of calm to the image.

We are continually drawn to the centre of the body at the top of Jo's left knee because it is at the very heart of the triangle and at the centre of the support. We are also drawn there by the lines of the bottom part of the kimono which form a second triangle with her knee at the apex.

Placing Jo absolutely centrally on the support adds to the feeling of calm and balance produced by the triangular composition. Asking the model to turn her head to one side and stagger the position of her legs in a relaxed pose breaks the symmetry to add a sense of movement.

golden rule

Triangles in composition

Many of the works of the Great Masters were founded on a sound geometrical composition which was designed to lead the viewers' eyes on a deliberate journey across the support. Most of these were quite complex but in Renaissance paintings of the Madonna and Child you will often see a simple equilateral triangle as the foundation of the composition because it gives a sense of calm, balance and dignity. You can see this in Raphael's 'The Madonna del Granduca' (c.1505), for example. Lucy has given this construction a modern twist by breaking the triangle with Jo's legs.

Colour

'In my life painting I only use three basic colours. I have always loved Prussian blue which is complemented by burnt sienna. The third colour I use is gold ochre, bought in error one day, which glows on the paper. This combination seems to give the painting all the depth and subtlety that is needed to suggest the warmth and strength of the human form.' Notice that these colours are all fairly transparent, creating a lovely light-filled effect when used in combination like this, but both Prussian blue and gold ochre are staining colours, leaving little room for manoeuvre when it comes to correcting errors.

The artist's palette

'I only use Winsor & Newton artists' quality paints and get through large quantities of my three basic colours, particularly burnt sienna which is a rather fleeting pigment and very translucent. Prussian blue tends to flood everything and take over, whereas gold ochre repels other pigments as it is slightly opaque. Getting the balance right is the tricky part, and learning which colour reacts in what way and how much water to use is what I spend my life doing. I also sometimes use indigo, Payne's grey and alizarin crimson. "Jo in Kimono" has quite a lot of Payne's grey in it; this has quite a bluish tone which I like.'

pointer

About ochre

Genuine ochres are made from natural earths which are totally lightfast and tend to have a subtle, slightly muted tone which is ideally suited to all natural subjects, not least the human form. The actual colours can vary quite substantially from brand to brand, so it is best for artists to try out a few before making a purchase. The gold ochre from Winsor & Newton which Lucy now uses as one of her staple colours is brighter and more yellow than the company's yellow ochre. It also has different qualities: whereas their yellow ochre is fairly opaque, gold ochre is much more transparent and staining colour.

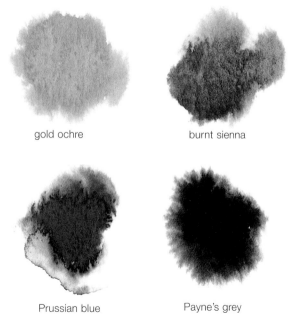

gold ochre

burnt sienna

Prussian blue

Payne's grey

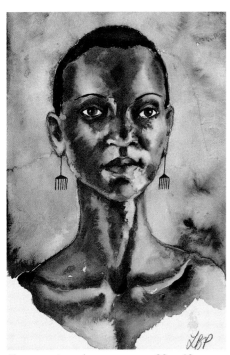

Karen watercolour on paper **60 x 40cm**

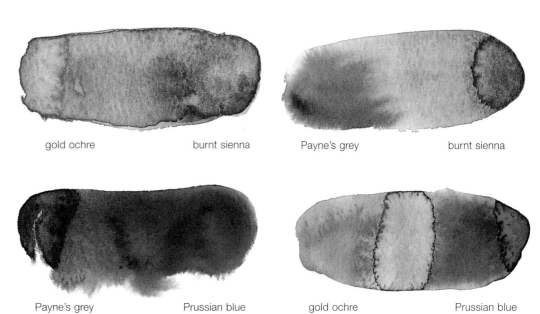

gold ochre burnt sienna

Payne's grey burnt sienna

Payne's grey Prussian blue

gold ochre Prussian blue

'For "Karen" I used almost exclusively burnt sienna and gold ochre with some Payne's grey. Luckily I had a very strong pastel drawing to base it on. The painting works so well because her skin tone is complemented by the burnt sienna.'

Technique

'I used to be a very detailed illustrator, trying for photo-realism all the time. My big breakthrough was going to a workshop run by Graham Dean, a well-known artist who announced that he had reinvented watercolour painting. He introduced me to handmade cotton rag paper from India called Khadi paper which is lovely to work on. He used a very limited palette of mainly Hooker's green and he got me to loosen up my style by applying the watercolour from the tube directly onto the paper and then throwing water at it. You cannot start fiddling with one-hair brushes, you just have to see what happens and lift off the water or add more paint while the painting is still wet. It keeps the painting spontaneous.'

Working wet-in-wet

Working with wet paint on very wet paper as Lucy does requires special techniques. First the paper must be wetted liberally, using a very wet sponge or large brush. Then, working quickly before the water starts to dry, the neat colour can be squeezed directly on to the paper or a very strong wash applied with a large brush. Immediately the paint starts to run all over the place. Colour can be encouraged to move in a particular direction by tilting the paper or blowing it with a hair-dryer, but the excitement of this way of working is that the artist can never be in complete control. Paint which runs into areas where it really can't be used can be lifted out with absorbent paper or a dry brush (see Shortcuts).

shortcuts

Lifting out colour

This technique can be used on wet or dry paint to soften the transition between washes or to lighten an area which is too dark. It has a more pronounced effect when the paint is still wet, as a large amount of the colour can be removed by simply wiping with a dry brush, sponge or paper towel. Once the paint has dried it can be lightened by gently scrubbing with a damp brush or sponge, using hot water for stubborn paint. Two of the colours which Lucy uses – Prussian blue and gold ochre – are staining colours which means that they can never be removed completely from the paper. This can be an advantage with a technique like Lucy's when what she wants to do is lighten the colour, not remove it. But it does make it difficult to correct any errors.

'Techniques vary, art stays the same.'
(Claude Monet 1840–1926)

The application of paint for the background is much looser than on the figure, and the colours are much paler so that they don't draw attention away from the subject.

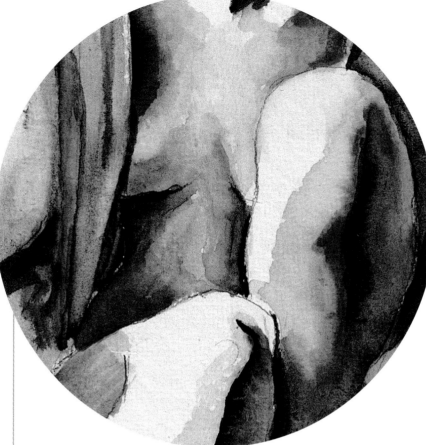

By overlaying washes of burnt sienna, wet-on-dry, Lucy is able to create the tonal variations which mould the form into shape.

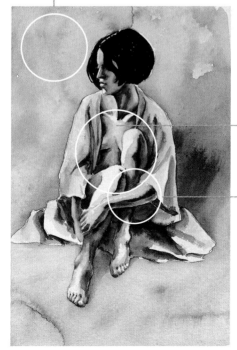

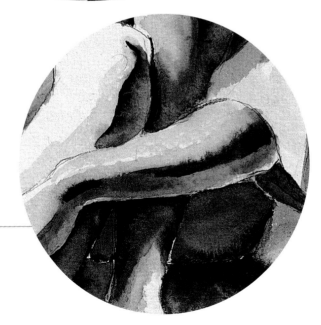

Here Lucy has applied the blue wash wet-in-wet to soften what would otherwise be a very hard shadow and help capture some of the softness of the skin.

STILL LIFE WATERCOLOUR

When you look at this painting you are probably first struck by the wealth and depth of colour, but interestingly this was not something which really bothered the artist when selecting the flowers for the set-up. She was more concerned with arranging the blossoms in the vase in an inspiring way: 'I don't think about colour when I'm choosing the subject or working out the composition. The colour comes later.'

Carol does a lot of figure painting but she is a versatile artist and enjoys landscape and still life work as well. 'I find still life an appealing subject because it affords a way to make an interesting painting out of objects that are everyday, simple, overlooked or just plain ordinary. If you have a particular attachment to an object it is even better. You can begin to choose imagery that has an emotional connection to you or the viewer which can then carry a deeper message.'

Spring Bounty by Carol Carter watercolour on paper **152.5 x 101.5cm**

'Beauty in art is truth bathed in
an impression received from Nature.'
(Jean Baptiste Camille Corot 1796–1875)

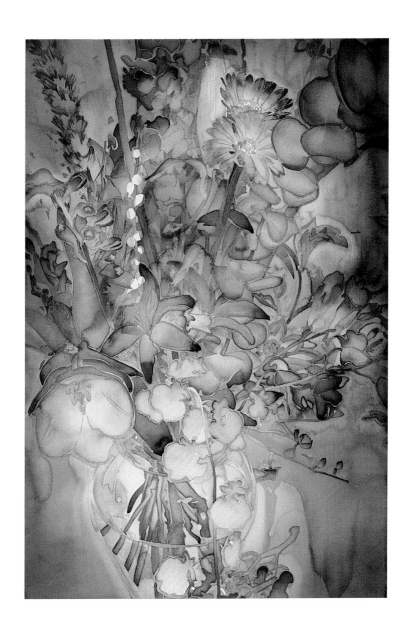

Composition

Carol rarely does any preliminary sketches for a painting so most of the compositional work is done when arranging the items in the set-up. At this point Carol looks primarily at form and shape: 'I look for relationships between scale of flowers, stems and leaves and I seek variety of shape in the overall arrangement. I also strive for rhythms and flow, particularly in the foliage.' Look at the rhythms of the eucalyptus leaves on the right, for example. They seem to revolve around each other, echoing the shapes of the brightly coloured daisies beside them. These contrast strongly with the more aggressive rhythms of the sword-like leaves on the right.

golden rule

Dealing with the background

When painting floral arrangements it is often a problem knowing what to do about the background. An elaborate background, such as an embroidered cloth, may take attention away from the flowers while a plain backdrop creates large dead areas. The space beside the vase can be especially problematic, particularly if the vase is tall and narrow. To get round this some artists add other objects to the set-up but Carol has found another solution by choosing a fairly short, fat vase in the first place, adding a few flowers around it and then cropping in on the floral display so tightly that she actually 'cuts off' some of the longer sprays, thereby reducing the area beside the vase to a minimum. She also paints the background in a fairly loose way to produce interesting colour variations which prevent this area looking dead.

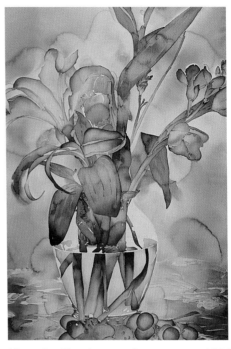

King-size Floral watercolour on paper **152.5 x 101.5cm**

Carol loves duality in her paintings so that the image seems to push and pull in different directions, leaving a certain sense of unease yet also creating an excitement. Here the arrangement is fairly simple and relatively limited in both shape and colour which you might expect to produce a calm mood. The bouquet is also fairly open which should enhance this feeling because there is no sense that the flowers are fighting for space. However, the use of complementary colours – orange and blue – is so powerful that it overrides the calm to inject tremendous energy. In this way colour and composition are in deliberate discord to disquiet us.

'I seek variety of shape in the overall arrangement. I also strive for rhythms and flow, particularly in the foliage.'

Carol zooms in on her subject, cropping off the vase at the bottom and the flowers at the edges so that they seem to burst forth from their confines. This, combined with the great size of the picture, produces an image of tremendous impact.

Our eyes usually look at the centre of an image first and if we find a focal point there it is somehow reassuring. Carol has placed the orange lilies here and they seem to leap out at us because of the contrast with the blue behind them. Wherever our eyes rove they always return here.

Notice how Carol has placed the vase just slightly off-centre. It is neither in the middle nor in one of the other traditional positions roughly a third or two thirds of the way across the support. Being unexpected, this produces a sense of unease – it is almost as if we feel the need to reach into the painting and move the vase.

Colour

Carol loves vibrant, saturated colours for both their seductive and confrontational qualities. She uses only Winsor & Newton artists' quality paints because they are capable of creating the depth of colour she requires. Notice the clarity and transparency of the colours she has chosen which make the paintings look as if they have been worked on silk or painted on glass. This is partly achieved by using many of the colours unmixed so that their true qualities shine through.

The artist's palette

Carol needed a large palette of paints to capture the rainbow of colour she saw in the petals and leaves of the bouquet in 'Spring Bounty'. Her palette included two yellows: aureolin (also sometimes sold as cobalt yellow) which is a bright, strong, clear, transparent yellow and Indian yellow which is softer and browner but still clear and transparent. She also used Prussian blue, a colour so strong that many artists are afraid to use it, but its depth, transparency and vibrancy make it a perfect addition to Carol's strong palette. Another interesting colour she chooses is Winsor violet, a rich, transparent colour which, like Prussian blue, is staining. Already you will begin to see the qualities she seeks in her paints – strong, clear and transparent. Indeed only cobalt turquoise and cadmium orange from among the 11 on her palette are opaque and more than half the colours are classed as staining.

pointer

Complementary colours

Complementary colours are those colours directly opposite each other on the colour wheel which, when laid side by side, increase each other's power and intensity (see pages 10–11). Thus orange placed next to blue or red next to green seem almost to sizzle and vibrate. Carol makes heavy use of complementary colours so that her paintings 'sing'. For example, the orange and blue totally dominate 'King-size Floral', each making the other brighter and stronger. She also uses near-complementaries such as yellow and blue which intensify each other but not to quite the same extent as using true complementaries – yellow and violet, for example.

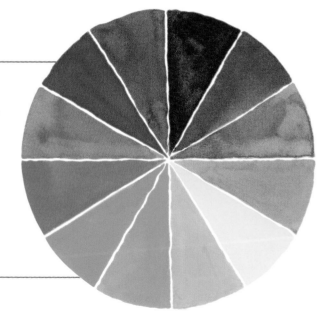

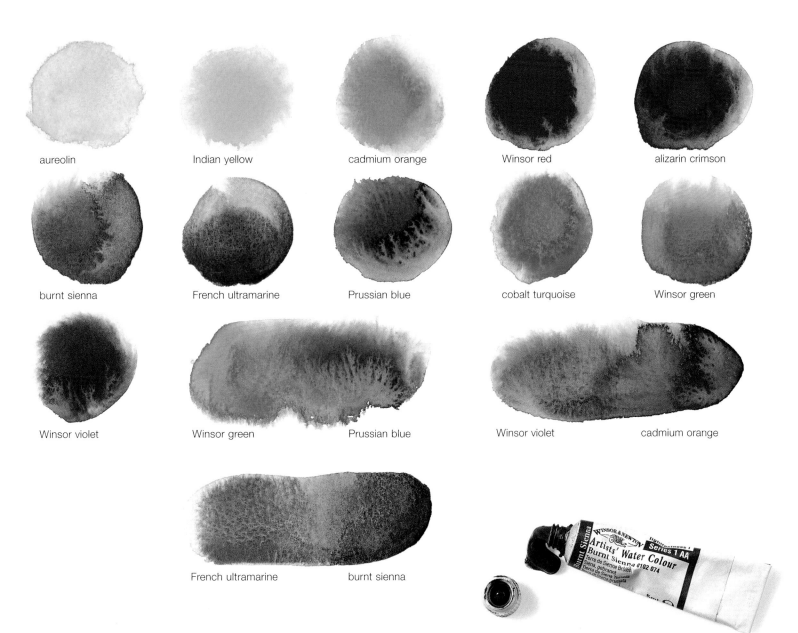

aureolin

Indian yellow

cadmium orange

Winsor red

alizarin crimson

burnt sienna

French ultramarine

Prussian blue

cobalt turquoise

Winsor green

Winsor violet

Winsor green

Prussian blue

Winsor violet

cadmium orange

French ultramarine

burnt sienna

Technique

Carol uses huge sheets of paper and generous pools of colour so she finds it easiest to work on the floor where she can allow the washes to 'puddle'. Most watercolour artists lay in the colours gradually, overlaying washes stage by stage until they eventually build up the required depth of tone. Carol works in her own way. Once she has plotted the forms of the set-up in pencil she starts by painting the background. 'After the background is dried I begin to paint in the subject, starting with the forms which are farthest away – in this case the leaves. I then work forward in the picture plane, finally ending up by painting the vase.' This is interesting because it is a method sometimes adopted by landscape artists. By starting with pale, bluish washes in the background and working forward with thicker, hotter colours, they are able to recreate the effects of aerial perspective so that distant objects stand back from the subject matter in the foreground. As you can see, it is a technique which also works extraordinarily well with floral still life arrangements.

Carol takes two to four days to complete a painting like this, working for a full eight hours each day. 'I typically work when it's raining so that the watercolour washes dry slowly and I am able to manipulate them with intense colour and clear water to make them look rich, fluid and spontaneous. I do not work in dry weather.'

Recreating the effects of aerial perspective

Aerial perspective is something most often associated with landscapes but it is still relevant to other subjects, even still lives. You can see it most obviously in a landscape or seascape where forms become bluer and greyer the farther they are away. This is due to the veiling effect produced by all the tiny particles of dust and water in the air and it obviously becomes much more apparent when a mist or fog descends. Colours seen through these veils are also muted – a scarlet flag on a ship will look much duller if the ship is a few kilometres away than it will if it is moored alongside you.

Going further than a simple figurative reproduction of the flowers in front of her, Carol turns the image into a statement about colour and form, yet we can still see where she is coming from and that this is quite clearly a vase of flowers. Notice that she has created the effect of aerial perspective by blurring, lightening and tingeing the foliage at the back with blue to push it behind the main display (see Shortcuts).

Notice the size of Carol's painting. Working large enables her to get 'right inside' the floral group and even 'enter' individual flowers to capture details without having to fiddle – working too small would encourage her to become too figurative and that would lose all the freshness and spontaneity of the work.

Here you can see how important form is to Carol. She hasn't made any attempt to mould the flowers because she is more interested in their overall shape and their contribution to the composition as a whole.

FIGURE&PORTRAIT WATERCOLOUR

Antony Williams works in oil, charcoal and egg tempera, but it is for his exacting egg tempera work that he is perhaps most admired. He paints still lifes of stunning realism and in his portraits captures the minutiae of surface detail with painstaking observation and without any attempt at flattery. The results are some incredibly detailed portraits which bring to mind the work of Hans Holbein the Younger (1497–1543), among others. Antony admits to influences from the past, but he also aims to be modern: 'I am influenced by the long tradition of self-portraiture in Western art, particularly by artists like Holbein and Dürer and, more recently, by Freud. Although my portraits can be read as being conventionally traditional, I also believe that they are properly modern as well.

'The main advantage of a self-portrait is the access you have to the model which allows for in-depth investigation into the physiognomy of the face. Working from myself allows me to get in closer than I would with a sitter and I can really scrutinise the surface detail and see, perhaps, more insistently than in life the little marks of wear and tear, the furrows and the wrinkles. This close-focus approach which gives every detail almost equal consideration can produce an effect or sense of heightened realism which is very different from photo-realism. Egg tempera is perfectly suited to this aim.'

Self portrait – Morning Light by Antony Williams egg tempera on board **66 x 56cm**

'My initial interest in self-portraiture stemmed from a situation when I didn't have access to any models or sitters, so I had to look to myself for a subject.'

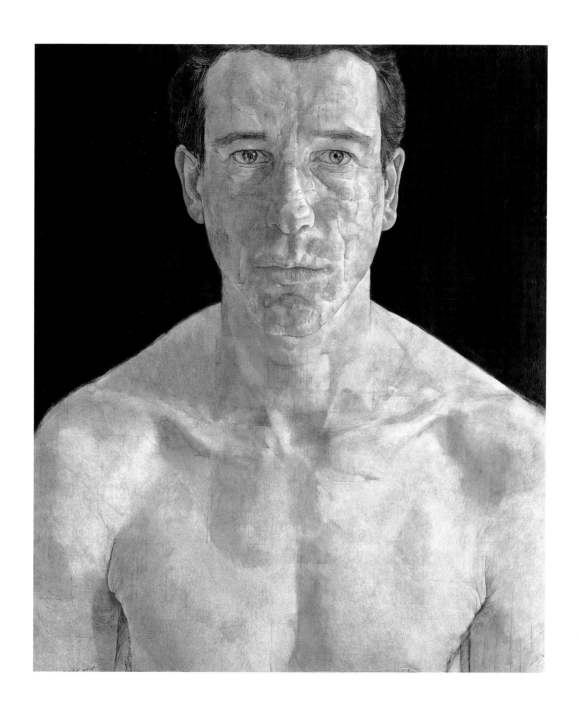

Composition

'When composing this self-portrait I decided to concentrate on the face itself and cropping the image very tightly. I kept the background minimal by using a very dark colour. The main focus of attention was to be directed at the centre of the face and by working on this area to the exclusion of any other information I could hopefully produce an image of intensity and presence.

Notice how the symmetry of the painting and its triangular underpinning provide a strength and solidity which is reinforced by the intensity of the man's gaze and his firmly set jaw. This is further reinforced by the stark contrast between the dark background and the pale flesh tones which focuses all attention on the man and gives him a statuesque quality. At the same time this contrast makes the man look human and vulnerable, setting up a duality which makes this painting hard to forget.

golden rule

Mirror, mirror
Although a face may look symmetrical, there are slight variations between eyes, eyebrows, ears and even each side of the nose which create subtle but distinct differences. So if an artist looks into a mirror to paint a self-portrait his friends and family may not think he has captured an exact likeness – something is just not quite right. Artists often overcome this problem by setting up two mirrors to reflect their image once and then back again. Alternatively they can work from a photograph.

Self-portrait II egg tempera on board **30 x 22cm**
Here again Antony has cropped the figure tightly to reduce the background to a minimum, this time choosing a pale grey colour for the background so that it does not draw attention away from the face. Notice that he has cropped off the top and back of the head which helps focus attention on the face and also makes for a more striking composition.

'Expression in painting demands a very great science of drawing; for expression cannot be good if it has not been formulated with absolute exactitude.'

(Jean Auguste Dominique Ingres 1780–1867)

 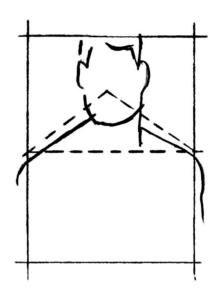

By focusing in close on the face and torso Antony reduces the background to a minimum; plain background areas are laborious to work in egg tempera and can distract from the main subject.

The near-perfect symmetry of the painting gives it a sense of dignity and calm which is reinforced by the triangle formed by the sloping shoulders. Triangles in composition have a strength and stability which has made them popular with artists for centuries – they were frequently chosen by Renaissance artists painting the Madonna and Child.

The greatest detail is concentrated on the face, with less on the torso and none at all in the background, helping to bring our eyes back to the face repeatedly. We are also drawn to the face by the contours of the shoulders which form a triangle with the nose at the apex.

Colour

Antony uses a palette of just eight colours, including two versions of one hue – vermilion. 'I made a conscious decision to use a limited palette in order to gain control over my use of colour and to give my paintings a unified look and feeling. The palette I have chosen suits the way I look and respond to the world around me. I rarely mix two colours together on my palette, but I create tonal ranges with each colour by adding progressive amounts of white to each.'

The artist's palette

'My palette consists of terre verte, Venetian red, yellow ochre, genuine vermilion, vermilion hue, titanium white, ivory black and Naples yellow deep. I occasionally add ultramarine deep to this basic palette.' This intriguing palette is steeped in history, including as it does some really traditional colours – yellow ochre, Venetian red and terre verte, as earth colours, would have been some of the earliest paint colours ever used, while the first vermilions were made to imitate a red used in the ancient world called cinnabar and have been in popular use for hundreds of years. Naples yellow, originally a lead-based paint, and ivory black are also traditional colours. In fact, the only relatively modern colour is titanium white which was first introduced in the 1920s and is the strongest white available.

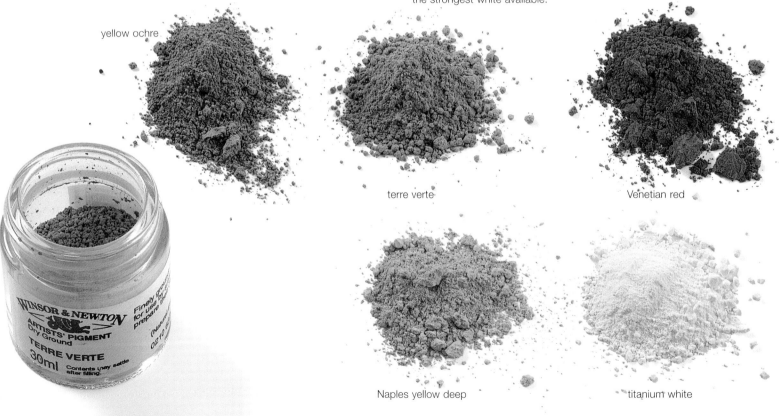

yellow ochre

terre verte

Venetian red

Naples yellow deep

titanium white

Antony's paints

'I usually buy my pigments in powder form, mixing them with distilled water to form a stiff paste and storing them in small glass jars. When I come to use them I remove enough pigment for a day's use with a palette knife and mix this with approximately the same quantity of egg yolk. The pigments are then set out in ceramic dishes and are ready for use.'

pointer

About ivory black

This black has a brownish tinge which gives it a slightly warm tone. The genuine paint was originally produced by sealing ivory scraps in iron pots and heating them until the ivory was charred. Then the crushed remains were made into a rich black paint which was lightfast, though expensive. The ivory scraps were often obtained from comb makers, but when ivory became too expensive paint suppliers turned to bone black, a paint obtained from charred animal bones, and simply changed its name to 'ivory black' which could command a higher price. Modern ivory black is still made from charred animal bones. It has a good tinting strength and is lightfast.

vermilion

ivory black

Technique

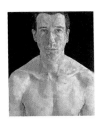

'I work on MDF which I prime with up to seven coats of gesso made in a traditional way with whiting and rabbit-skin glue. The panels are then sanded to a very smooth surface and coloured with washes of yellow ochre tempera to kill the brilliance of the white gesso. I begin a self-portrait by drawing in black tempera with a fine sable brush on the yellow ground. I use measuring lines to establish the main relationships (this approach is similar to that employed by William Coldstream). The process is repeated later in the picture to make sure errors have not crept in, and these marks and lines can often be seen in the finished work, owing to the translucent nature of egg tempera.

'Once I have established a detailed monochrome drawing, I begin the underpainting for the flesh in terre verte, a neutral green. This is applied with small sable brushes. Over this warmer colours such as Venetian red and yellow ochre are added. I am very interested in the contrast between warm and cold colours, and I allow the green underpainting to show through the warmer layers above.

'Tempera dries almost instantly, so it is virtually impossible to physically blend colour on the panel as you can with oils. Shadows and flesh tones have to be built up by using small touches of colour which could be described as being almost pointillist in approach. Egg tempera is an unforgiving medium and to produce a finished painting can take months of hard work, but I believe the results are well worth the struggle.'

'To produce a finished painting can take months of hard work, but I believe the results are well worth the struggle.'

shortcuts

Terre verte underpainting
Terre verte, also called green earth, was once commonly used for underpainting flesh tones. In fact, it was so widely used for murals and on wood panels that all the known deposits of good clay have long been used up. Today's genuine green earth clays are often strengthened with other pigments or dyes but the colour is basically the same – a dull, earthy green with a weak tinting strength.

With egg tempera the paint dries almost the moment it touches the support, so each brushstroke is left to stand for itself. This means that Antony almost literally has to paint every hair on his head.

The careful approach which tempera demands enables Antony to put great detail into the face, but it requires a lot of looking and plenty of hard work.

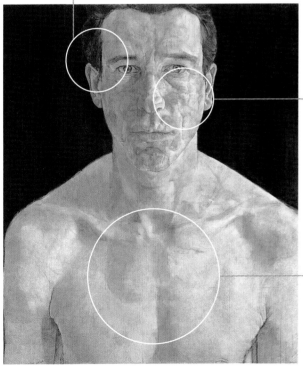

The thin black lines which add texture to the body are actually Antony's measuring lines,used to establish relationships and check the accuracy of the figure's proportions.

Figure & Portrait 97

LANDSCAPES WATERCOLOUR

'There is something beautifully serene and yet threatening about the rainforest, twisting and dense, where I spent a month painting from the field station of the Iwokrama Rainforest Research Programme on the Essiquibo River in Guyana. I had spent a month here the year before, and wanted to return. Here you can sit without a person in sight but with teeming life all around.

 'While painting from the Iwokrama research station I was taken up river to this peaceful spot, surrounded by towering trees and the sounds of macaws and howler monkeys. The boatman came back for me at dusk. The area is pristine, the sand red, and a giant turtle had made her way up the bank to dig a hole for her eggs.'

The Iwokrama Rainforest, Amazon Basin by Shirley Felts watercolour on paper **46 x 56cm**

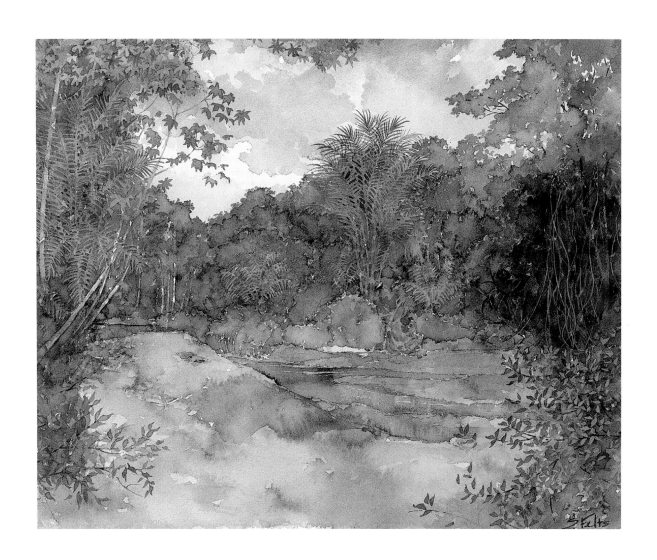

Composition

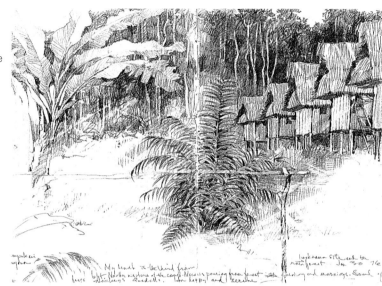

'Although I select my viewpoint carefully, with the best possible composition in mind, I also edit what is in view. I paint what excites me, but I do set out to find it.' Even surrounded by all the lush beauty of a rainforest, Shirley still took time to select the most pleasing viewpoint. In the end she chose to paint a small clearing where a gap in the tree canopy allowed plenty of light to filter down to the rich red earth. This clearing is important in the painting, because without a break in the vegetation the scene would have no real focal point and the eyes would have no place to rest from the busy activity of the leaf shapes. 'Painting in the rainforest was particularly difficult – I thought wonderful – such abundance and confusion.'

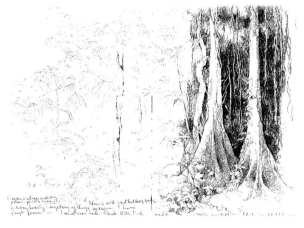

'I focus on one thing, edit and build around it.'

Shirley ensures our eyes are trapped within the painting and cannot leave by 'fencing them in' at the sides with the lush vegetation.

The tranquillity of the scene is enhanced by the symmetry of the composition – not only do the side borders of vegetation seem twinned, but the patch of blue sky at the top is reflected by the open ground at the bottom.

Our eyes are drawn along the diagonal gully into the depths of the painting, and are then attracted to the large palm almost at the centre whose form in turn echoes the leaf shapes in the foreground. By keeping our eyes circulating in this manner, the painting retains our interest.

golden rule

Symmetry

A symmetrical composition produces a balanced, harmonious and therefore restful image, but this format should be selected with care because if a scene is too symmetrical it may appear static and dull. Shirley has avoided this potential problem by choosing a composition which is not perfectly symmetrical. The areas of sky and land are not exactly matched and the enclosing vegetation at the sides is varied and interesting.

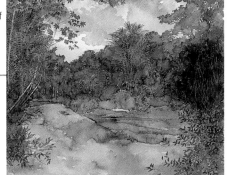

Colour

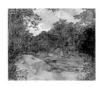

Dense undergrowth is a difficult subject to attempt because of the problems of definition amongst all the mass of green. Shirley successfully overcomes this by placing light tones against dark, dark against light, a device known as counterpoint. Sometimes she lets the white of the paper show through to create the effect of flickering light, elsewhere she simply overlays paint to place deep, inky greens against lighter, warmer ones. Warmer colours tend to advance while cooler ones recede, so Shirley has painted foreground leaves in greens warmed with a little yellow or burnt sienna, and cooled the distant areas with a little ultramarine – whether they actually looked that way at the time or not.

The artist's palette

Shirley uses a limited palette, favouring plenty of sap green, ultramarine, alizarin crimson and burnt sienna.

cadmium yellow

vermilion

alizarin crimson

ultramarine

burnt sienna

sap green

sap green ⟶ ultramarine sap green ⟶ cadmium yellow burnt sienna ⟶ alizarin crimson

pointer

Tonal variation

In a painting like this, tonal variation is particularly important, both to suggest depth in the undergrowth and to create a lively and interesting effect. In general, because of the effects of aerial perspective, distant regions appear lighter, but where undergrowth is concerned it is the dark tones which punch through to the depths.

Technique

Shirley paints in the traditional style, wet-on-dry, leaving one wash of paint to dry before applying another – in the intense heat of the rainforest it would be very difficult to paint any other way, though she does manage a little wet-in-wet work in the undergrowth to suggest hazy light filtering through. She makes great use of a No. 4 series 7 Winsor & Newton sable brush, using the very tip for fine details, such as the narrow leaves of the palms, pressing harder on the brush to splay out the head when painting larger areas such as sky and earth.

shortcuts

Working wet-in-wet
This means exactly what it says – applying wet paint on top of wet paint or paper. It creates wonderfully soft washes of colour which run, blend, spread and fade to create all sorts of misty effects and produce fabulous new colours. It's not particularly controllable because you can't tell what will happen, though this is also part of its charm, and it's best not to over-use it because it can leave a picture looking formless and undefined. Because of the amount of water involved the paper should be stretched unless it is very thick – Shirley used very heavy Not Arches paper.

As Shirley builds up colours by overlaying washes wet-on-dry, she is careful not to overwork the painting – some areas have only a hint of colour, while others have successive washes of the same colour to create great tonal depth and variation.

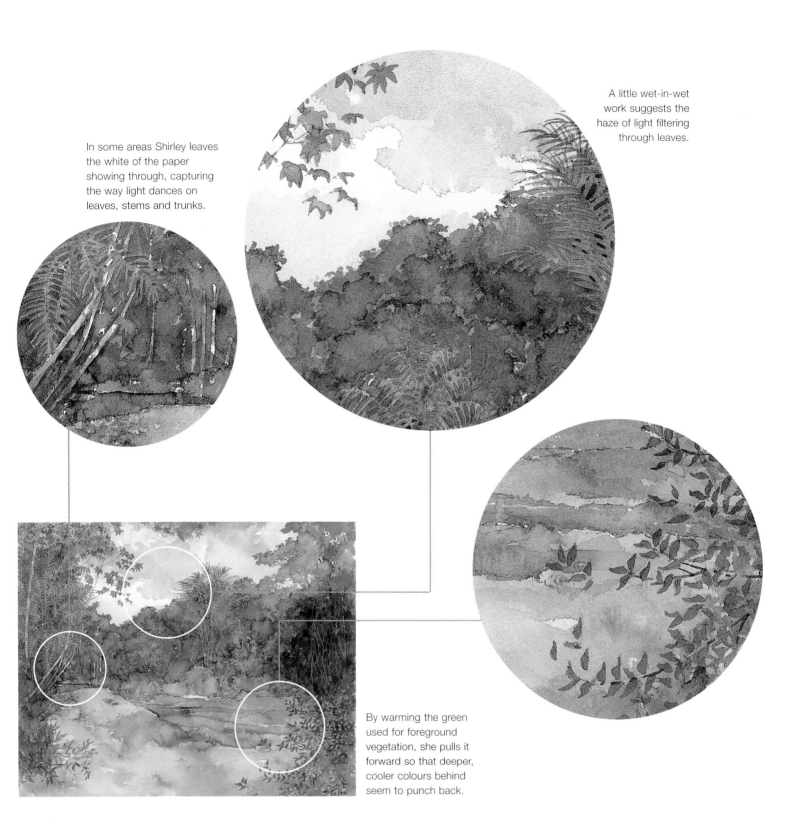

In some areas Shirley leaves the white of the paper showing through, capturing the way light dances on leaves, stems and trunks.

A little wet-in-wet work suggests the haze of light filtering through leaves.

By warming the green used for foreground vegetation, she pulls it forward so that deeper, cooler colours behind seem to punch back.

LANDSCAPES GOUACHE

'My painting is about sensations –
not illusions

This is a picture about spring-time, 'when on a bright and breezy day one turns, shoulder on to the wind, with colour turned up, eyes a little screwed up against the dazzle of bright light, noticing that the warmer weather is drawing up new growth.'

'First Growth' isn't a depiction of a specific place but rather a kind of emotional and visual summing up of the landscape, light and colour of a Spring day in the Pennine region in which Stephen now lives. As he says, 'I wish not to make a representation of a particular place but use a place or view of a place, and especially the weather, the lighting and colour, as a starting point from which to allude to other qualities.'

First Growth by Stephen Court gouache on paper **33 x 43.7cm**

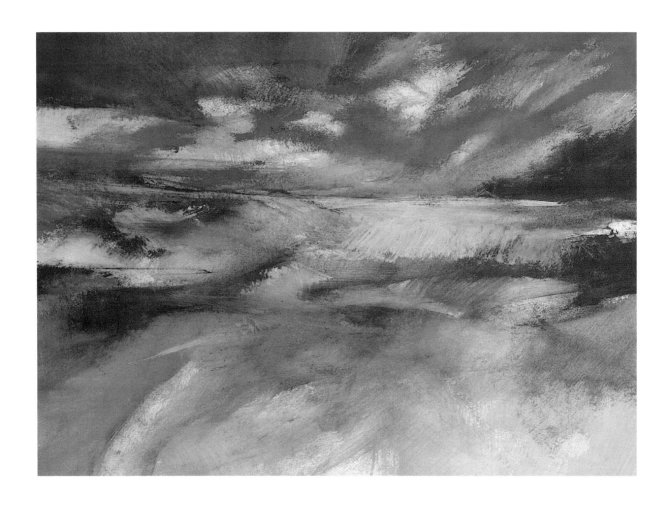

Composition

This composition is based on a notional viewing point from an elevated site, looking across a valley space to rising hillsides at an equal or greater altitude to that of the viewing site. 'In the area where I now live, in the Pennines, this upland formation is a common feature, and one-third sky to two-thirds land seemed to suit the way I wanted to make the picture.'

Stephen creates his compositions through the careful orchestration of colour and texture, playing off warm (advancing) and cool (recessive) colours, thin, smooth paint layers and thicker, more textured layers. He relates this very much to music in which 'the colour relationships and textures make the pattern of the tune, and the masses make the chords and themes.'

Stephen has plotted the horizon roughly two-thirds of the way up the picture area, giving plenty of room for him to express the sense of space one feels as well as sees as one looks across a valley to the hills beyond.

The strong lemon yellow paint is placed to draw the eye continuously over to the horizon. This is achieved by using the colour lightly but widely in the foreground, then intensifying it at the horizon. The splashes in the sky also seem to force the eye back down to that same horizon.

golden rule

Leading the eye

If your painting is one of many in a gallery, you'll want to do something to draw attention to it. This can be done consciously, but many artists do it instinctively. Stephen uses colour to pull the viewer into his painting, a technique which works well. You can use colour lavishly, as Stephen does, or use it sparingly, setting off a small area of bright, hot colour in an otherwise cold picture, for example. You can do the same thing with line – paths, gates or the roll of a hillside can draw viewers in – or with framing, placing bushes or trees at the edges to prevent the eye from straying. If you are painting from life, simply adjust your position to take advantage of these effects which occur naturally.

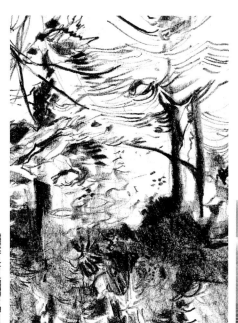

'A piece starts from little more than a wish to try something out.'

While the yellow paint skims us straight across to the far hills, the cool green and blue in the valley, which are recessive colours, seem to fall away above and below, giving us the sensation of flying over a chasm or of being drawn into the painting.

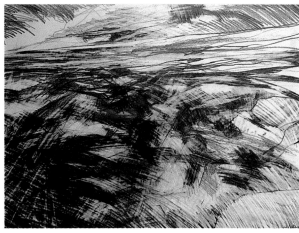

Stephen went up in a glider to take this reference photograph to aid his painting.

Colour

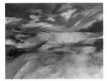

For Stephen, colour is inexorably linked to composition. He starts his paintings with colour, rather than in the traditional way with a pencil sketch, so that 'the picture is made, or rather becomes made, firstly from a notion established from washes and areas and pieces of colour played as a sort of dance. These areas of colour are forged, refined, pushed, pulled and elaborated as the piece progresses.' While he paints he holds in his mind the various things he wishes to deal with so that 'the work is, as it were, driven along'.

The artist's palette

Stephen used a very limited range of colours in this palette. He chose Daler Rowney and Winsor & Newton Designers' Gouache, noting that it is a highly versatile and handy paint amongst the water-soluble paints. He points to its good covering power, with relatively high pigment content, 'finely ground enough to obtain tints and washes'. Adding gum arabic to the diluted paint, he says, 'can afford lush and lustrous qualities similar to ink glazes', while used dry and pasty, gouache 'gives scope for nylon or steel spatula and dry-brush handling'.

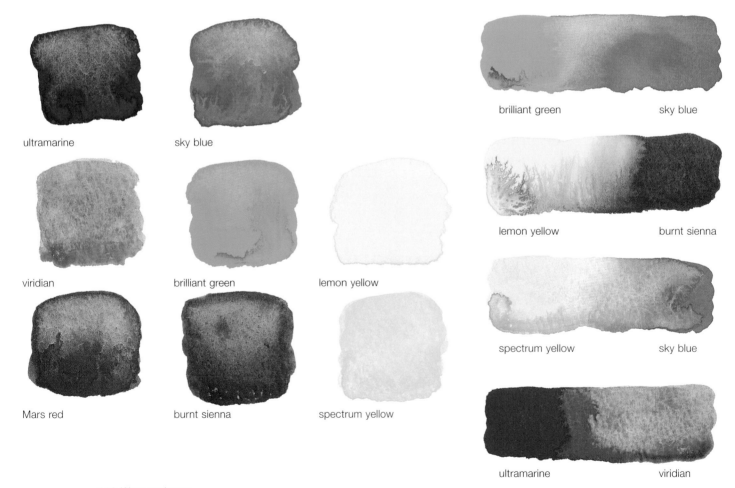

ultramarine sky blue

viridian brilliant green lemon yellow

Mars red burnt sienna spectrum yellow

brilliant green sky blue

lemon yellow burnt sienna

spectrum yellow sky blue

ultramarine viridian

Colour durability

Some gouache – or watercolour – paints are prone to fading, sometimes in a matter of weeks or months, sometimes over a number of years. To ensure his paintings are durable, Stephen always refers to the colour-makers' claims for lightfastness in the small range he uses and, as he says, 'would not trouble with fugitives [colours which fade] or semi-durables knowingly'.

The durability of a colour depends on the pigment(s) used, the quality and brand. That means that you can't always assume that a certain named colour is lightfast – different brands marketing a colour under the same name may use different pigments (see right) – so always refer carefully to the manufacturer's information charts to avoid disappointment.

Names and brands

If you run out of a favourite colour and can't find your usual brand in your local art shop, don't assume that another brand will do. Another brand's lemon yellow, for example, could be significantly lighter, warmer or more fugitive. Check the colour index number on the tubes to find the closest match to the one you want. Generally you'll find the artists' ranges contain better pigments than the more economical students' ranges.

About yellow

The first yellow pigments were obtained from a range of natural materials, some of them bizarre. Indian yellow, for example, came from the concentrated urine of cows fed on mango leaves and denied water; gamboge came from tree sap and was highly fugitive; while there was even a yellow derived from gall-stones. Today's manufactured yellows are generally more reliable, though some, such as gamboge, are not very lightfast. Naples yellow, yellow ochre and the cadmium yellows are recommended. Naples yellow contains lead, so as an alternative you can mix your own. For a warm version Stephen suggests mixing titanium white with a hint of pale yellow and burnt sienna; for a cool version add a hint of sky blue to the mix.

Technique

Stephen prepares himself mentally as well as physically for a painting. 'It is well to enjoy the preparation, one's tools and materials assembled, then, taking a breath deeply and slowly, gather the idea and cast marks and shapes directly. Draw together or slice apart whole sections, mastering and massing the elements of the composition so that it sits well in its space.'

In this painting he used a 3/4in (2cm) fitch and a small turkey sponge to lay the washes and to work the paint, sometimes wiping the colour with the side of his hand. In other paintings he might apply the paint fairly dry and pasty so he can use a favoured old 4 3/4in (12cm) broad-body white hog, a spatula blade or rag to steer and draw the paint 'sweeping and nudging it to form the shapes around the pictorial space'.

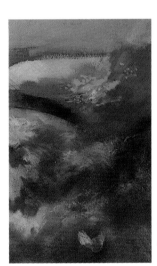

In 'Harvest Home' Stephen used gouache colours and also fine-ground pigments mixed with PVA glue medium, handling the paint with fairly large brushes, the smallest being a 3/4in (2cm) fitch, wiping with his hand, and shifting colour about with a rag. He also used spray canisters of motor paint to effect 'dustings of atmospherics and modelling of spaces in the composition', a technique learned from fellow artist Denis Bowen.

Harvest Home gouache and cellulose on paper **67 x 42.5cm**

'A picture space is a place to play and experiment.'

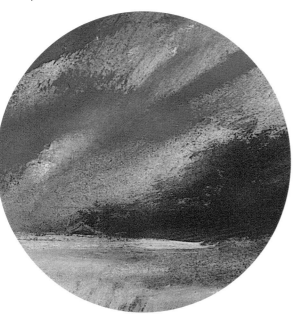

In some areas Stephen used the paint fairly dry and pasty so he could steer the paint with his white hog, spatula blade or a rag.

shortcuts

Gum arabic

Gouache already contains gum arabic as a binder, but by adding a little more, as Stephen points out, you can give the paint qualities similar to ink glazes. Gum arabic can be bought in bottles and added to water when mixing paint to give it more body and to make it less runny and easy to blend. It can revive colours by enriching them and adding a slight glaze. However, it can cause cracking if used neat, and should always be mixed with a high proportion of water – experience will teach you how much.

Using spray canisters (aerosols) of motor paint enables him to reproduce the look of atmospherics.

SEASCAPES WATERCOLOUR

Cecil Rice has made over 20 trips to Italy, several of which have been specifically to paint in Venice. 'I tend to walk around the city in the first few days of the trip, doing small sketches in pencil, pen and watercolour. It was on one such foray that I first discovered the canal which featured in "Canal with Washing". This was a particularly dramatic, silent, narrow canal with sheer walls reaching up to what seemed like a chink of light. Several boats had been moored along the canal and washing had been hung out to dry in true Italian style between some of the upper windows. I sat down at the end of the canal to paint this watercolour on the spot.'

Cecil's motivations for painting particular scenes are mixed. 'There is no doubt that I am a romantic. I am attracted by the atmosphere of old and historic buildings, particularly Romanesque and Gothic architecture as well as dawns and sunsets, and if water forms part of the subject then this often makes for additional magic. Reflections in water have a life of their own whilst relating to other elemental parts of a scene. For example, in painting an enclosed Venetian canal one has the water reflecting the buildings which are solid and stony. The shapes of the doorways and windows are static but the reflections of these shapes in the water are moving.'

Canal with Washing by Cecil Rice watercolour on paper **35 x 25cm**

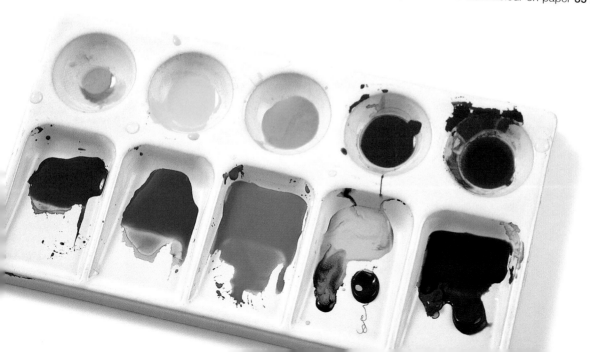

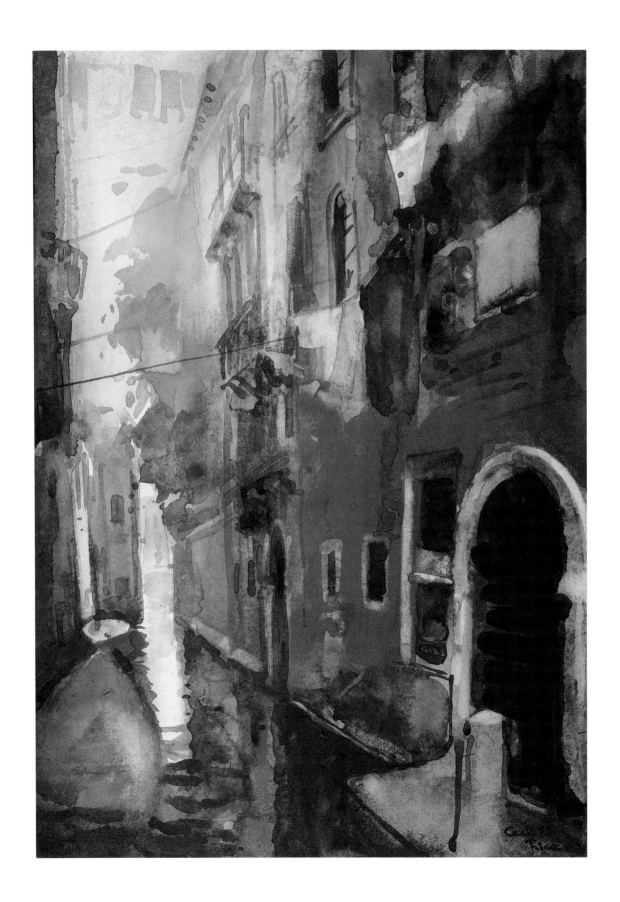

Composition

'I always seem to start with an intuitive idea of the completed painting. Then I have to decide what will go into the painting and what will fall outside the edges. I look at the view in terms of extremely simple shapes, but shapes which nonetheless lock together like pieces of a jigsaw.

'I believe in sound drawing at the outset and for this reason my preliminary sketch or sketches have to be accurate. In painting a canal I can't look for the horizon or its relation to the rectangle in which I will be composing. Nevertheless, it is possible to look for the edges of roofs, for example, and to notice the way that these shoot away in perspective towards a hidden point. Either side of the canal are many verticals – drainpipes, windows and even chimney breasts – which it is often useful to draw, either in light pencil or directly with a fine brush, so as to gain markers within the total composition.'

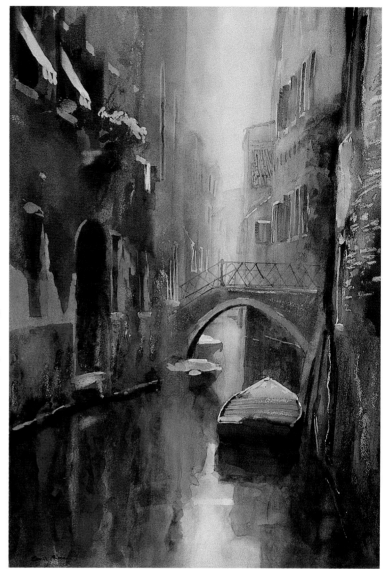

Canal, Venice watercolour on paper
The majority of waterscapes are painted in landscape format because this best suits the shape of the object being painted and creates a sense of openness and release which suits a lakeside scene or seascape. Here Cecil has chosen a portrait format because the atmosphere is very important to him and he wanted to capture the sense of narrowness – how the buildings almost fall in – which one feels in a small Venetian canal. Notice how the sides of the support brace the buildings, conferring them with additional solidity and weight.

As an added bonus the format gives Cecil plenty of space to play with the colours reflecting off the buildings and into the shadows. 'Looking upward in an enclosed Venetian canal may reveal a clear sky and the effect of Adriatic sunlight not only highlighting upper storeys but causing a tremendous light-filled warmth of colour penetrating down across the architecture. I'm attracted by how the brightest light in the painting gives way to the coolest of shadows.'

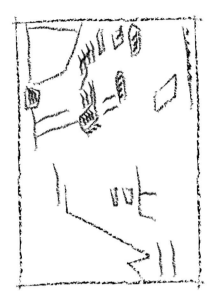

Cecil points out that with a canal scene there is often no horizon in view. This is the key line which most landscape or seascape artists start from in their compositions. Since he can't start there, Cecil uses the edges of the buildings as key lines instead, here plotting the opening between the rows of buildings close to the left edge of the paper. This off-centre positioning helps to create a sense of intrigue – twists and turns which arouse our interest and draw us deeper in.

Colour can be used compositionally as a means of leading the viewer's eyes around a painting. Here the clear, pale light at the end of the canal is echoed by the stark white of the enormous archway on the right of the picture and by some of the washing on the balconies and lines. Their contrast with the dark shadows gives them added drama to draw our eyes inexorably on.

Lines are another compositional device because we are naturally drawn along them. Here our eyes move rapidly from one side of the canal to the other along the washing lines; they dash up and down the lines of the balconies and windows and sweep along the bottom of the buildings. These lines contrast with the zigzag reflections in the water and the dappled foliage of the trees, keeping us constantly entertained.

golden rule

Getting references how you can

Although Cecil does make preliminary sketches in pencil, pen and watercolour, he likes to paint on site as much as possible, usually starting with quite a detailed drawing which he may erase as the painting progresses. However, life doesn't always run in the way we would like, and sometimes he has to make do with what he can get. When he returned to the site of 'Canal with Washing' with a view to making additional paintings, he found the view completely blocked by street vendors. 'I was so determined to get a second chance to paint from this vantage point that I slipped behind the stall and onto a very precarious sort of ledge. Realising that I was beaten, I whipped out my Nikon SLR and took a photograph, the only thing I could do without falling into the canal.'

Colour

Colour is obviously very important to Cecil since it overflows from his paintings with a radiance which is almost heart-rending. This is partly because of his interest in light, which is filled with the colours of life, and partly to do with his response to the atmosphere but it is also down to his inner eye. 'Many of my colours echo those naturally found in the subject but at the same time I quite often "see" a patch of wall or a tract of water inwardly as an area of pure colour. I can't explain this easily but it has to do with intuition and I often incorporate such an area into the composition as it reveals itself to me. Provided the addition of such an element within the design does not upset the sense of the painting as a whole it usually enhances the work dramatically.'

The artist's palette

Cecil uses a large range of colours, preferring Winsor & Newton artists' watercolours in 14ml tubes because they don't run out too quickly and they are slightly more economical. He also sometimes uses Rembrandt tube colours too. He mentally divides his palette into two sections – 'primary' and 'earth' colours. Under his primary palette he cites new gamboge, cadmium yellow, lemon yellow, cadmium red, alizarin crimson, French ultramarine, cerulean blue, cobalt blue and Prussian blue. As his 'earths' he lists yellow ochre, Naples yellow, raw sienna, burnt sienna, light red, Indian red, raw umber, Payne's grey and lamp black.

'In addition to these colours I usually allow myself the option of viridian. I use no other greens and I nearly always mix my own. I avoid pre-mixed versions such as sap green and Hooker's green as well as some of the more lurid or synthetic violets.' Although he includes Payne's grey and raw umber in his palette he likes to mix his own neutrals too, finding that this produces a much richer colour span. 'I particularly value the range of earthy browns, greys and violet colours one can get from mixing French ultramarine with either light red or burnt sienna. Cobalt blue and burnt sienna or light red also give a delightful range of shadowy colours.'

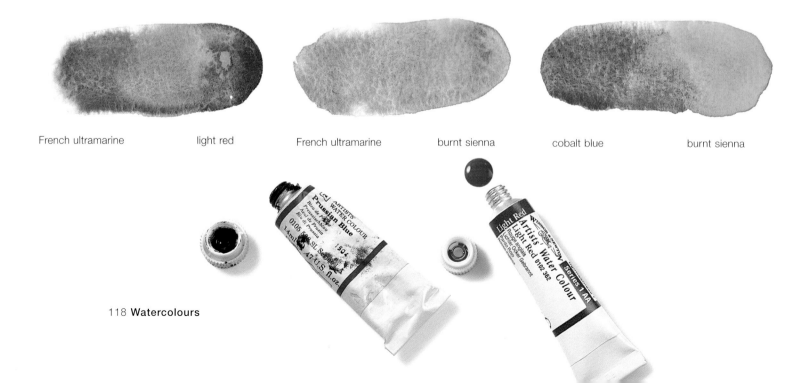

| French ultramarine | light red | French ultramarine | burnt sienna | cobalt blue | burnt sienna |

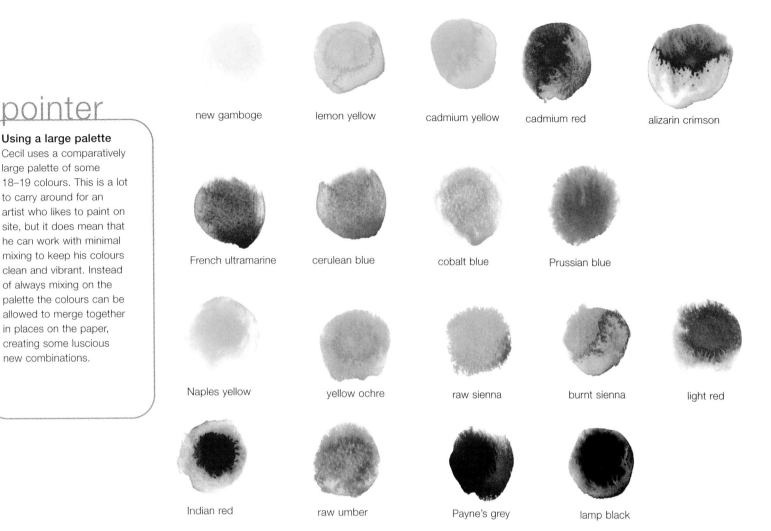

new gamboge　　lemon yellow　　cadmium yellow　　cadmium red　　alizarin crimson

French ultramarine　　cerulean blue　　cobalt blue　　Prussian blue

Naples yellow　　yellow ochre　　raw sienna　　burnt sienna　　light red

Indian red　　raw umber　　Payne's grey　　lamp black

'You'll understand, I'm sure, that I'm chasing the merest sliver of colour. It's my own fault, I want to grasp the intangible. It's terrible how the light runs out. Colour, any colour, lasts a second, sometimes three or four minutes at most.'

(Claude Monet 1840–1926)

'There are many things to consider and many possible ways of starting a picture.'

Technique

Cecil starts his paintings with a light line drawing. This may be done with a soft, preferably 2B pencil, but sometimes he works directly with a brush, particularly if he is after a spontaneous impression. 'I don't bother with squaring up. If something looks wrong I rub out gently and correct it, and as soon as there is enough of a "scaffold" established I get the paints ready. I tend to try to foresee a good number of colours or mixtures of colours and I use largish mixing dishes for big paintings. I can start the actual painting in a number of different ways, sometimes by drawing thinnish lines with dilute colour or sometimes by soaking the stretched paper universally with clean water and a large, soft brush. I may wait for some of the moisture to penetrate the paper thoroughly and for some of it to evaporate, leaving a semi-damp surface into which I can work. I may start with a very thin colour cast using transparent colour such as new gamboge, raw sienna or Prussian blue.

'Having started the work I do tend to follow a logic relating to the tonality of the painting. It is traditionally thought to be a good idea to build up tone by degrees from lighter to darker in watercolour and I usually follow this principle to start with.'

shortcuts

Working wet-in-wet

Wet-in-wet work is a feature of most of Cecil's work and he finds that 'wonderful fusions of colour on the paper can lend a great deal to the build-up of atmosphere'. The technique sounds simple enough – you simply dampen the paper with clean or coloured water and then apply colours on top so that they spread and merge. However, control can be a problem. Although a certain amount of anarchy with this technique makes it more exciting for the artist and creates some spectacular, if surprising, results, giving the paint too much free rein can create dark tones where you want light ones and push edges out of position, for example. Cecil says that the dampness of the paper is a critical factor. 'If the surface is too dry or too wet then the paint will either form an undesirable solid mark or flow out uncontrollably across too large an area. If just right then the paint applied should be absorbed into the fibre of the paper, softly enhancing surrounding colours and forming an intensifying underlying colour.'

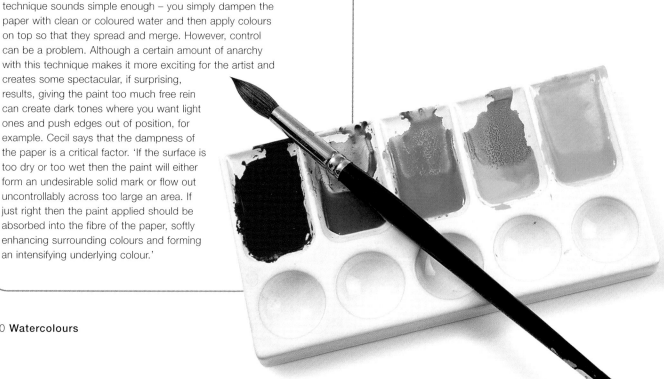

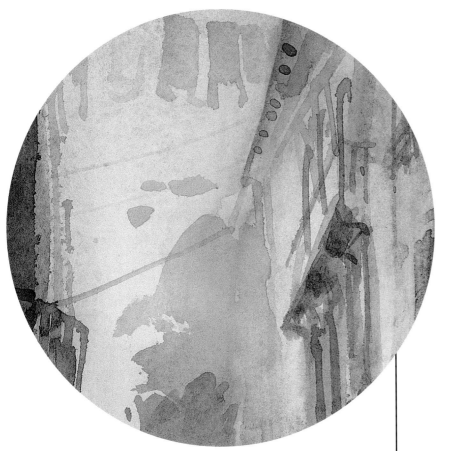

White objects are wonderful for artists who are interested in light effects and who love colour. They act like natural reflectors as light bounces colour onto them from surrounding objects. Sometimes they look genuinely colourful, but if not the artist can enhance them by adding colours, working instinctively or by design. Cecil fills his whites with colour, helping to show the way light filters down from the sky and creating a moody, romantic atmosphere.

By applying translucent wash over translucent wash Cecil builds up shadows of great depth. Where washes overlap strange shapes appear and we are encouraged to peer deep into these areas in the same way as we look into real shadows to make out the partially obscured objects there.

The contrast between areas of wet-in-wet, like this, where colours merge, granulate and flocculate, and the areas of wet-on-dry like the shaft of light on the water where edges are crisp and hard, creates a visual excitement which makes the heart beat a little faster.

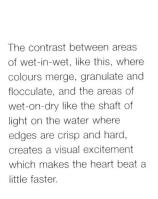

Portfolio

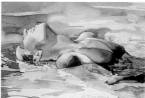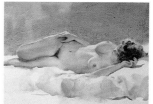

CAROL CARTER is an established St. Louis-based painter working primarily in large-scale watercolours and acrylics. She has exhibited extensively both regionally and nationally, including 15 one-person exhibitions and numerous invitational and group exhibitions. Her work is represented in many public and private collections including those of Blue Cross/Blue Shield, Boatmen's National Bank, Citicorp, Leonard Slatkin, Price University and Utah State University amongst others. Carol is represented by Peter Barlow Gallery in Chicago. To view more of her work contact her at:
4450 Laclede Avenue
St. Louis
MO 63108
USA
or visit her web site:
www.carol-carter.com

TREVOR CHAMBERLAIN ROI RSMA worked as an architectural assistant until 1964 when he started painting professionally. His main subjects of interest are the figure, marine, town and landscape subjects in which he concentrates on capturing the atmosphere and light. He generally paints alla prima from life. He has won many awards, held 16 one-man shows and exhibited some ten works at various Royal Academy Summer Exhibitions. He exhibits his work regularly in the UK and abroad and has published two books on oil painting: 'Oils' and 'Oil Painting Pure and Simple' and a book on watercolours entitled 'Trevor Chamberlain – A Personal View: Light & Atmosphere in Watercolour'. His work has been featured on British television and he has contributed to two programmes for Connecticut Television. Contact him at:
Target Gallery
7 Windmill Street
London W1P 1HF
UK
Tel: +44 (0)20 7636 6295

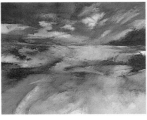

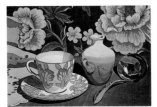

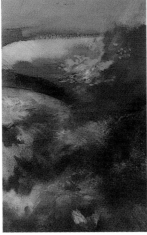

MARJORIE COLLINS was born in Chicago and trained at the University of Michigan where she obtained a degree in Fine Art. She moved to England in 1975 but continues to exhibit her work in the USA as well as in England. She has exhibited at the Royal Academy Summer Exhibition; the Hunting Prizes; Singer & Friedlander/*Sunday Times* Watercolour Competition; the Royal Institute of Oil Painters; the Royal Institute of Painters in Watercolour; and the Royal Watercolour Society. In 1992 she won the Daler-Rowney Purchase Prize for a floral still life and in 1999 she won the Winsor & Newton Grand Prize Award for a still life in watercolour. Her paintings have also been shown in a number of magazines and books.
Contact her at her studio:
28 Hayward Road
Oxford OX2 8LW
UK
Tel: +44 (0)1865 552 591
or email her at:
marjorie@painthouse.fsnet.co.
UK

STEPHEN COURT is predominantly a landscape painter whose concerns 'are about ways of looking, seeing, showing and sharing'. He studied at Yeovil School of Art and Birmingham College of Art & Design and won a Royal Academy David Murray Travelling Scholarship. He not only paints himself but has taught painting, drawing, print and graphics.To view more of his work in the UK, contact:
Lupton Square Gallery
1–2 Lupton Square
Honley
Huddersfield HD7 2AD
or:
The Loggia Gallery
15 Buckingham Gate
London SW1E 6LB
or:
Tidal Wave Gallery
3 Bridge Street
Hereford HR4 9BW
or:
Cupola Gallery
178A Middlewood Road
Sheffield S6 1TD

KATY ELLIS graduated from The Glasgow School of Art in 1995 and in the same year won the Royal Scottish Academy's John Kinross Scholarship for painting in Florence. The following year she won the Stoke-Roberts Painters and Stainers Travel Award and also the Winsor & Newton Young Artists Award for Watercolours. She travelled and painted extensively during 1996 and 1997 in Italy. View more of her work at:
The Burford Gallery
High Street
Burford
OX18 4QA
UK

SHIRLEY FELTS graduated from the University of Texas in 1960. She has travelled widely, sketching and painting in Japan, Nepal, America and South America. Her work is in public and private collections in Britain and abroad. She has illustrated books for adults and children and in 1995 won the Conservation Book Award for 'The Blue Whale'. In 1996–7 she worked as Artist in Residence for the Iwokrama Rainforest Research Programme in Guyana. One of her paintings was presented, in 1996, to the late President of Guyana, Dr Chedd Jagan. View more of her work at:
Alex Gerrard Fine Art
Bell Lodge
Vinehall
East Sussex TN32 5JN
UK

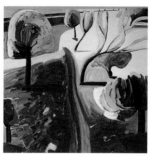
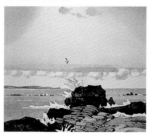
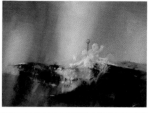

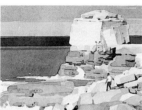
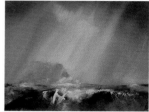

RON JESTY was formerly a graphic designer and has painted all his life. His subjects are largely derived from still life and the land and seascapes of west England. Ron is the author of 'Learn to Paint Seascapes', Harper-Collins, and contributes to 'The Leisure Painter' and 'International Artist'. His work has also been included in several books on drawing and painting. He has held one-man shows including at the Brewhouse, Taunton; Art Centre, Yeovil; and The Gallery, Dorchester. He has exhibited at the RWS annual and Royal Academy Summer Exhibitions. Contact him at:
24b Brunswick Street
Yeovil
Somerset BA20 1QY
UK
Tel: +44 (0)1935 426 718

THIRZA KOTZEN studied at the University of the Witwatersrand, Johannesburg; the Central School of Art & Design, and the University of Oregon. She has won numerous awards and honours and has considerable teaching experience. Impressively she has held 11 one-person exhibitions, many at the Curwen Gallery in London but also in Johannesburg, and has participated in many group exhibitions around the world. Her pieces are held in private collections and by a range of institutions including IBM, Bank of China and Anglo American. View her work at:
Curwen Gallery
4 Windmill Street
London W1P 1HF
UK
Tel: +44 (0)20 7636 1459
or email her at: thirzakotzen@compuserve.com

PETER MISSON is a self-taught artist. Despite the considerable promise he showed as an artist in his youth he turned his mind towards the sea and it was only in the early 1980s that he started to take art more seriously again. He studied the work of the Masters, often copying their drawings in the art school tradition and has spent the last 20 years developing his style and finding his own voice through paint. Contact him at:
223 Farm Hill
Exeter
Devon EX4 2ND
UK
or view more of his work at:
Mid Cornwall Galleries
St Blazey Gate
Par
Cornwall PL24 2EG
UK

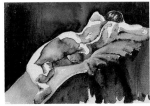

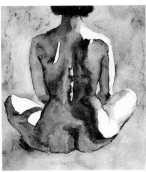

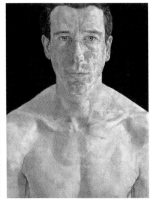

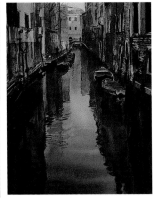

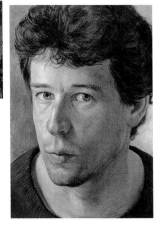

LUCY PARKER obtained a BSc in Biology before taking a course in illustration and working as a commercial illustrator for a software company. After a short break to have children, she began painting for herself and started to exhibit her work. She now also teaches drawing and painting and works mainly in watercolour on hand-made paper. Her passion for life drawing is reflected in her work, although she has also embarked on landscapes, trying to capture the light at Cape Cod where her recent series was painted. She is chairman of the Fiveways Artist Group in Brighton, England. Contact her at:
47 Cleveland Road
Brighton
East Sussex BN1 6FG
UK
Tel: +44 (0)1273 502 552
or visit the Fiveways Group web site at:
www.crabfish.co.uk/fiveways.htm

CECIL RICE graduated from Brighton Art College. He has a passion for Italy, especially Venice, which he visits regularly on painting trips. His meticulous attention to drawing is evident in many of his paintings and it is this, combined with a fluidity and breadth in handling light and colour, that gives his work its strength. His work has been exhibited widely in England. View more of his work at:
Red Dot Gallery
22b Bellevue Road
London SW17
UK
Tel: +44 (0)20 8672 6086
or visit their web site:
www.reddotgallery.com

ANTONY WILLIAMS works almost exclusively in egg tempera, a demanding medium but one which allows him to express his feelings about the world. His work can be found at the Royal Society of Portrait Painters and in private collections in England, Ireland and the USA. In 1995 he was the first winner of the Ondaatje Award for Portraiture which won him a commission to paint HM the Queen for the Royal Society of Portrait Painters, who have the painting in their headquarters in London. Contact him at:
Philip Solomon
30 Keverstone Court
Manor Road
Bournemouth BH1 3EX
UK
Tel: +44 (0)1202 392 161

Glossary of Colours

Here is a brief guide to the different qualities of paint colours used by the artists in this book. Note that paints vary from brand to brand and from medium to medium so always check with the manufacturer's descriptions of the paints. For best results use a good brand of artists' quality paints such as those by Winsor & Newton.

alizarin crimson – popular violet-red; transparent; oil colour can crack if it is applied thickly; watercolour is prone to fading when applied thinly; not totally lightfast

aureolin – also called cobalt yellow; warm yellow, giving clear washes; transparent; permanent; staining colour

brilliant green – bright, light green; opaque; fairly lightfast

burnt sienna – clear earth colour made by heating raw sienna; similar to Indian red; transparent when very diluted, opaque with less dilution; absolutely lightfast

burnt umber – made by roasting raw umber; transparent when very diluted, opaque with less dilution; absolutely lightfast; fairly powerful tinting strength

cadmium lemon – the lightest, coldest yellow; greenish; very lightfast; quite strong tinting power

cadmium orange – intense bright orange; opaque; lightfast; fairly powerful tinting strength

cadmium red – bright, warm red; opaque; totally lightfast; good tinting strength

cadmium scarlet – similar to cadmium red being opaque and permanent but a warmer colour; powerful tinting strength; staining colour

cadmium yellow – clean and bright; opaque; lightfast; reliable

cerulean blue – bright greenish blue; opaque; tends to granulate; lightfast; quite low tinting strength

Chinese white – type of zinc white but with good covering power; cold; bright

cobalt blue – originally derived from crystals; transparent; lightfast; weak tinting strength

cobalt turquoise – blue-green; fairly opaque; lightfast; useful for painting water

French ultramarine – see ultramarine

gamboge – warm yellow colour; the genuine version is highly fugitive although Winsor & Newton's version is permanent; transparent; staining colour

gold ochre – more orange in colour than yellow ochre and fairly transparent (yellow ochre is opaque); lightfast; staining colour

Hooker's green – a mid green which varies in colour and quality from brand to brand

indanthrene blue – a transparent, red-tinged blue from Winsor & Newton; permanent

Indian red – originally derived from red earth; economical brown-red; absolutely lightfast; covers well

indigo – deep, inky blue originally derived from plant leaves; may be fugitive

ivory black – originally derived from charred ivory but now made from charred animal bones; warm to neutral black; opaque with good covering power; absolutely lightfast

lamp black – slightly bluish black; basically made from soot which has been heated to remove any oil; opaque; extremely strong tinting strength; totally lightfast

light red – earth colour; generally opaque; absolutely lightfast

Mars red – originally derived from iron oxide; generally opaque; absolutely lightfast; good mixer

mauve – similar to ultramarine violet but slightly darker; as a watercolour it granulates; transparent; permanent

Naples yellow – usually a delicious blend of cadmium yellow and white; opaque; lightfast

new gamboge – deep yellow; genuine gamboge comes from tree resin and isn't permanent but new gamboge is; transparent

Payne's grey – soft blue-black; lightfastness depends on the brand; covers well

permanent magenta – fuchsia pink colour; usually transparent; lightfast; staining colour

permanent rose – lighter, fresher pink than permanent magenta; transparent; lightfast; staining colour

phthalo blue – intense blue, also called phthalocyanine; transparent; lightfast; strong staining colour

phthalo green – vibrant blue-green; highly transparent; lightfast; very strong tinting and staining power

Prussian blue – deep greenish blue; transparent; very powerful tinting strength; lightfast, though some brands bronze with age; similar in colour to the reliable phthalo blue

purple madder – rich red-wine colour; transparent; permanent

raw sienna – soft yellow earth colour; good opacity; absolutely lightfast

raw umber – warm brown earth colour; cool, greenish brown; can darken over time; lightfast

rose madder – originally derived from the madder plant; wonderful soft rose colour; transparent; some brands are extremely fugitive so check with the manufacturer's details before you buy

sap green – originally produced from buckthorn berries; soft, earthy green; lightfastness varies according to brand but may only be moderate

sepia – originally derived from the ink sac of cuttlefish or squid; dark, black-brown; lightfastness varies according to brand

sky blue – intense cool blue; transparent; lightfast; strong tinting power

terre verte – green earth pigment used since early times; fairly opaque; lightfastness depends on the brand; low tinting strength

thioindigo violet – a red-violet from Winsor & Newton; bright; clear; fairly transparent

titanium white – inexpensive bright white; not

as toxic as flake white; very opaque; absolutely lightfast

ultramarine – originally derived from lapis lazuli and therefore highly prized; wonderful bright violet-blue; transparent; absolutely lightfast; good tinting strength

Vandyke brown – the true pigment comes from decomposed vegetable matter and isn't lightfast, but modern paints sold under this name are usually made from modern materials and vary from totally lightfast to moderately so; a cold, earthy brown; generally transparent

Venetian red – earth colour now often made from a synthetic iron oxide; hot red-brown; opaque; absolutely lightfast

vermilion – a bright, intense orange-red, similar to cadmium red; moderately lightfast

vermilion hue – very similar to vermilion but usually more reliable; lightfast

viridian – excellent, strong, clear bluish green; lightfast; transparent; stains overlaid colours readily

Winsor blue – Winsor & Newton colour which is basically phthalo blue; strong; transparent; permanent

Winsor green yellow shade – a strong mid-green from Winsor & Newton; quite transparent; lightfast

Winsor red – rich red colour; transparent to semi-transparent; lightfast

Winsor violet – Winsor & Newton watercolour; bright; transparent; staining colour; lightfast

yellow ochre – muted yellow earth colour; generally strong; similar to raw sienna but more transparent; absolutely lightfast